DEC 07 — Mar 08 = 4

DEC 07 — Mar 08 = 4

Robert Kipniss

Paintings 1950–2005

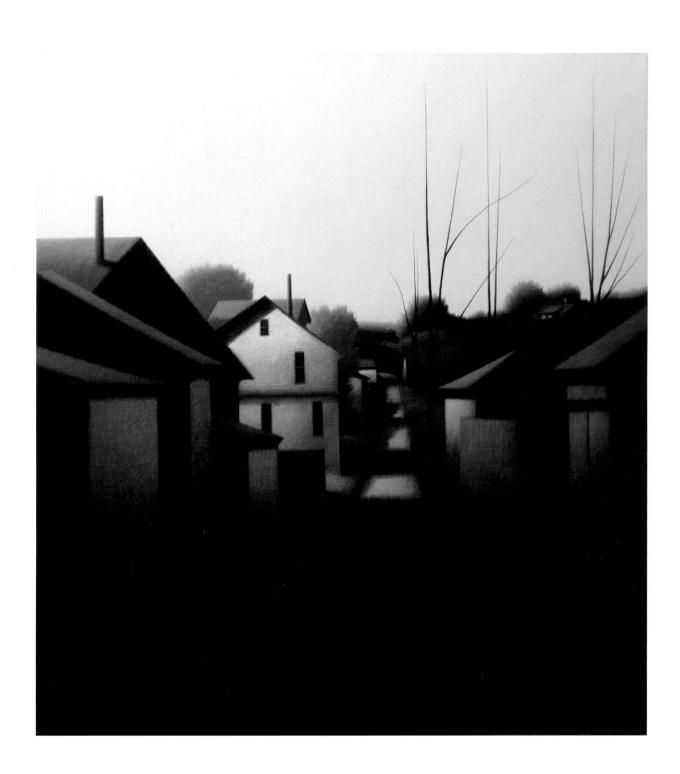

Robert Kipniss
Paintings 1950–2005

Foreword by E. John Bullard
Essay by Richard J. Boyle

HUDSON HILLS PRESS
NEW YORK AND MANCHESTER

For Laurie

Additionally, I would like to express my deep gratitude for the strong, heartfelt support of my work by the late Murray Roth and Muriel Werner, and to Gerhard Wurzer, James White, Rowland Weinstein, Philip Allen, Daniel Piersol, and William Beadleston.

First Edition

Copyright © 2007 Robert Kipniss

Published in the United States by Hudson Hills Press LLC, 3556 Main Street, Manchester, Vermont 05254.

Distributed in the United States, its territories and possessions, and Canada by national Book Network, Inc. Distributed outside of North America by Antique Collectors' Club, Ltd.

Executive Director: Leslie van Breen
Designer: David Skolkin / Skolkin + Chickey, Santa Fe, New Mexico
Editor: Laura Addison
Proofreader: Laura Addison and Linda Bratton
Production Manager: David Skolkin
Color separations by Pre-Tech Color, Wilder Vermont
Printed and bound by CS Graphic Pte., Ltd., Singapore
Founding Publisher: Paul Anbinder

Library of Congress Cataloging-in-Publication Data
Boyle, Richard J.
 Robert Kipniss : paintings 1950-2005 / by Richard Boyle and John Bullard. — 1st ed.
 p. cm.
 ISBN: 978-1-55595-280-8 (alk. paper)
1. Kipniss, Robert—Criticism and interpretation. 2. Landscape in art. I. Bullard, E. John (Edgar John), 1942- II. Kipniss, Robert. III. Title.
 ND237.K54B69 2007
 759.13—dc22
 2006036052

Page ii: Plate 24
Page viii: Plate 91
Page xii: Plate 58

Contents

Foreword
E. John Bullard
ix

Solitude and Silence: The Paintings of Robert Kipniss
Richard J. Boyle
1

The Plates
23

Notes from the Studio
129

List of Plates
133

Selected Publications, Collections & Exhibitions
141

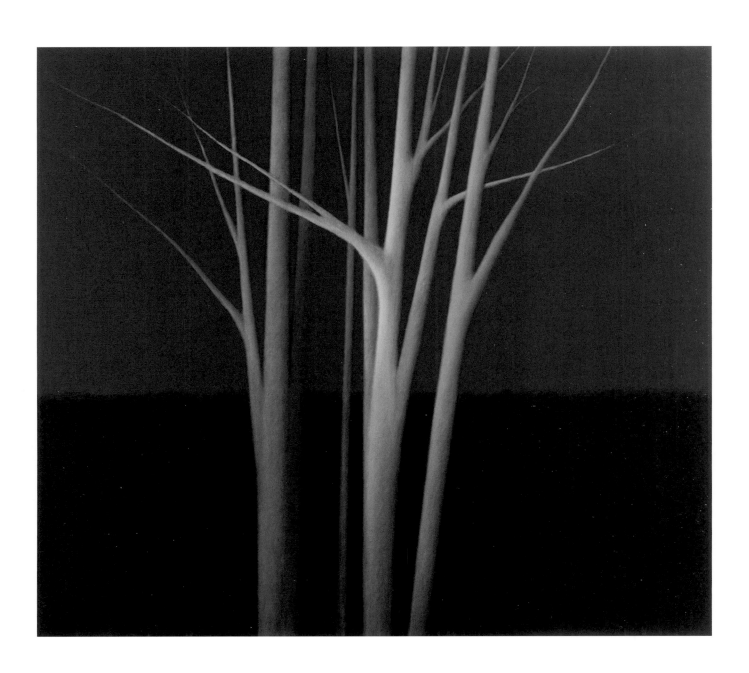

Foreword

There is something uniquely wonderful about the paintings and graphics of the American master Robert Kipniss. Certainly he has developed a distinctive and original style in depicting landscape and still life subjects, quite unlike any other contemporary American artist. I was introduced to Kipniss's work some years ago when our curator of prints and drawings, Dan Piersol, returned from New York after meeting the artist, excited by the possibility of organizing a retrospective of his graphic work. The project moved ahead, works were selected, a catalogue was prepared, other museums signed on to present the exhibition. Then on August 29, 2005, Hurricane Katrina devastated New Orleans and the Gulf Coast, forever changing the lives of millions of Americans and the future of our museum. We were forced to close our doors for six months, lay off 85% of our staff, and begin the slow process of recovery.

Not only were we blessed that our art collections survived intact and our building and sculpture garden sustained only minor structural damage, we also had a beautiful exhibition—*Seen in Solitude: Robert Kipniss Prints from the James F. White Collection*—with an accompanying catalogue ready to go as soon as the museum could reopen. Rather than install the show in our works on paper galleries as originally planned, I decided to present it in our larger first-floor special exhibition galleries and to supplement the eighty-six graphics with thirty-five recent paintings by Robert Kipniss, coming directly from his studio, most never publicly exhibited before.

I felt that the quiet beauty, the meditative silence, and exquisite craftsmanship of Kipniss's paintings and prints would provide our visitors with much needed comfort and relief from the destruction surrounding them throughout the city. The New Orleans Museum of Art reopened on March 3, 2006, with Kipniss and his family and friends in attendance. Even though only one third of the residents had returned to the city and there were few tourists in town, 6,500 visitors came to the reopening the first weekend. And the visitors did crowd into the Kipniss show and spent much time contemplating the vision of tranquil serenity found in his work.

During the ten weeks the Kipniss show was on view in New Orleans, I had the pleasure of seeing the works numerous times, both during public hours with our visitors and by myself when the museum was closed. Each person brings her or his own life experiences to the viewing of works of art and thereby our lives influence how we see and react to a particular painting or graphic work. For me, from the first time I saw Kipniss's work I thought of Zenga, paintings by Japanese Zen Buddhist monks and priests. This happens to be an area in which our museum has extensive holdings and I have visited Japan many times over the years to seek additions to our collection and to visit the many Zen temples and rock gardens. Zen is the contemplative tradition of Buddhism. The serenity found in Zen art and architecture, I also see in Kipniss's work. The solitude of Zen meditation brings to mind Kipniss's isolation while working in his studio. And just as a Zen artist limits his subjects to a few iconic images, Kipniss concentrates his creative energies on inspired variations on landscape and still life themes.

In Japan the primary purpose of Zen painting is to instruct and to inspire. Historians of Japanese art have identified seven distinct characteristics of Zenga: asymmetry, simplicity, austere sublimity, naturalness, subtle profundity, freedom from attachment, and tranquility. The reductive simplicity of Kipniss's landscapes, especially those images of closely viewed trees (such as *Nocturne with Six Trees II*, 2004, and *Testament*, 2005), embodies for me the spirit of Zen thus defined. While there are no obvious religious references in his work, I find a spirituality in Kipniss's paintings and prints that is missing in most contemporary art. The twilight lyricism of many of his landscapes, with muted colors and soft edges, could almost be scenes in Japan. His obvious love of and empathy with nature, a national passion for the Japanese, are evident even in his haunted and surreal images, like *The Balanced Rock II,* 2004. Robert Kipniss's paintings and

prints have provided me with solace and peace during a time of great stress and challenges. I know that his work has inspired similar feelings in the multitude of viewers who have seen his work across the country during the past fifty years.

E. JOHN BULLARD
The Montine McDaniel Freeman Director
New Orleans Museum of Art

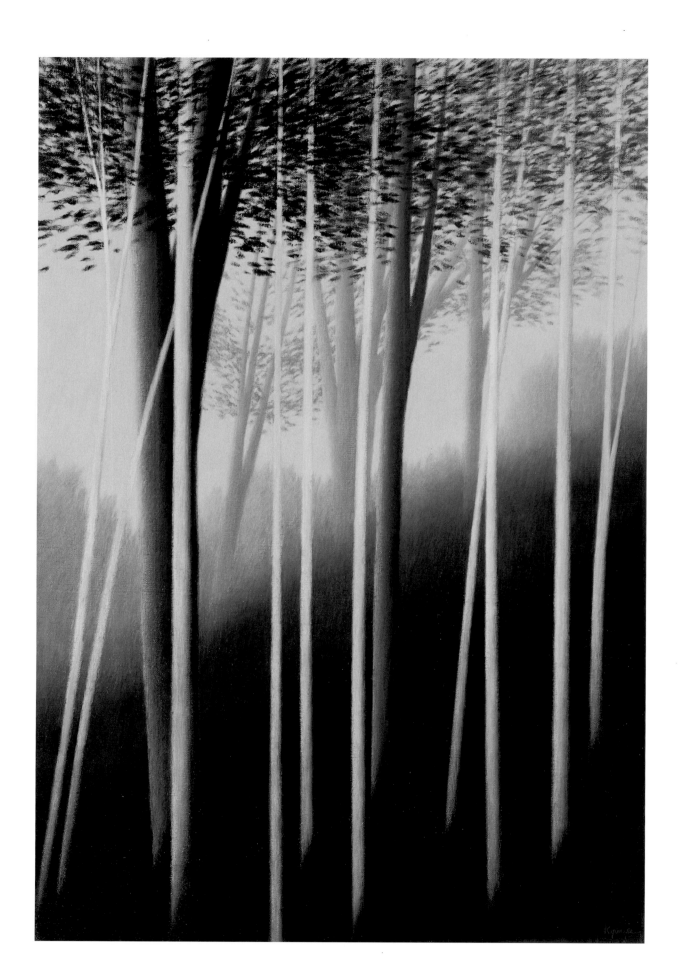

Solitude and Silence:
The Paintings of
Robert Kipniss

"Best of all . . . is the Small Still-life With Landscape—so unexpected
it is as though the art of painting were being rediscovered." [1]
—LAWRENCE CAMPBELL, *ArtNews*, October 195?

The paintings of Robert Kipniss seem to have a very special kinship with the poetry of Rainer Maria Rilke (1875–1926). In his preface to a special edition of *The Selected Poems of Rainer Maria Rilke*, Professor Harry T. Moore praises the German poet's use of "rich, symbolic pictorial complexities." Kipniss's paintings are notable for the same. This statement is, in many ways, more apt than it first appears. The poet was no stranger to the visual arts. He admired Cézanne's paintings, was Rodin's secretary and friend, and his imagery is exceptionally visual in the same way that Kipniss's imagery is exceptionally poetic. [2]

Robert Kipniss produced ten superb original lithographs in perfect harmony with the spirit of this unique Rilke publication. He had been given the choice of any poet whose work he wished to illustrate, and he chose his favorite. In so doing, Kipniss joined the distinguished company of such artists as Manet, Picasso, and Matisse, as well as his peers Alex Katz, Jim Dine, and Larry Rivers, all of whom illustrated the work of contemporary poets. However, Robert Kipniss originally *wanted* to be a poet; he only decided to concentrate solely on painting in the early sixties. [3]

Kipniss began writing poetry in 1948 and, at that time, he was accepted into the liberal arts program at Wittenberg College (now University) in Springfield, Ohio, which would later play an important role in the development of his painting. At the same time, he continued to paint assiduously. As a poet, he treated the elements of landscape and still life as a vocabulary; as a painter, he was a driven and compulsive worker and by the early fifties he had two one-man shows in New York City. Ultimately, he had to make a choice. He had come to a crossroads on a journey he has called his "odyssey." As Kipniss describes it, "Work is...an odyssey, and I have no concern about where it will lead, being content to discover my path as I pursue it."[4] That path, his odyssey, had its beginnings in the then little rural community of Laurelton, Long Island, where his family moved in 1936.

There was a long tract of woods about a half block from the Kipniss family home where Robert enjoyed playing by himself, alone with his thoughts and his imagination. As Rilke wrote in *The Solitary* (*Der Einsame*), "Among this rooted folk I am alone . . . to me the distant is reality."[5] It was an early indication of Kipniss's preference for solitude, for self-sufficiency, which he continued even after his family moved in 1941 to Forest Hills in Queens, New York, where there were still wooded areas prior to the post–World War II building boom. "Whatever vision is," he once wrote, "I know that mine began in the woods near our home on Long Island where I played as a child. . . . I preferred playing alone inside the edges of the woods, venturing further bit by bit as I grew older." He would venture further bit by bit in the development of his painting as well. "Later, as a college student I continued to seek . . . through lengthy walks through the alleys of the small college town in Ohio. There . . . I began taking walks mostly at night, and sketching from memory the next day. The elements that remain a large part of my imagery all my working life began to emerge in these sketches: mysterious windowless houses, backyard fences, trees leafless in the off-season. . . . My work remains unpopulated because I can then become as if the lone inhabitant, and when the work leaves my hands, who stands before it becomes for a moment me, alone, there."[6]

In the history of Western art, forests, like mountains, were represented first as threatening, then later as romantic. In Kipniss's art this imagery encompasses an entire world of thought and emotion. The imagery of trees in Kipniss's work is sometimes claustrophobic, as in *Hillside Illusions II* of 2001 (see plate 58), or sometimes threatening, as in *Springfield, O.*, 1991 (see plate 24); there is a sense of mystery in *Forest Interior* (fig. 1), or a joyous and elegiac feeling in *Before*

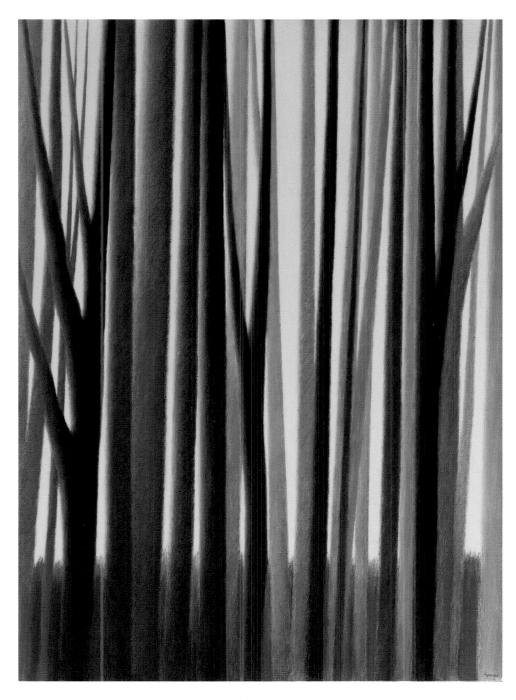

figure 1
Forest Interior, 2001, oil on canvas, 40 × 29,

Spring of 1998 (see plate 37), with its masterful subtlety of color and tone. or *Silver Morning* of 2000 (see plate 49); or it can be as distant and as detached as the view of the tree from a room in the film-noirish *Still Life with Two Vases* of 2002 (see plate 69). Yet regardless of the thought or emotion, mood or atmosphere, the imagery of trees is enormously important to him and has its origins in those

solitary early experiences. Further, he has distilled from this world a style that is distinctive and individual. Like a person, each painting has its own personality and temperament, yet they are related to one another by an intensity of emotion combined with an enduring patience of method.

In 1945 Kipniss attended Forest Hills High School, but was not very attentive in class. He much preferred to draw—and to play pool. He learned the game at age fourteen and he continued playing for the next twenty-seven years; he loved it from the beginning—that and billiards—and he was a natural. He loved the color of the table, the colors of the balls, and the skill and grace of the shots; he thoroughly immersed himself in it—he even dreamed about it. He was a serious player earning extra money right up to the day he quit the game. Kipniss's love of pool and billiards is reminiscent of that of another artist, the early Philadelphia modernist Arthur B. Carles (1882–1952). Like Kipniss, Carles was a painter with an independent temperament and a highly individual style. He also loved the sheer aesthetics of the game, and his daughter once wrote about his advice to an aspiring art student: "'tell him to play billiards. On that green surface and within that frame he will find the equilibrium, symmetry, triangulation, direction, motion and restraint of all art.'"[7] It is doubtful that Robert Kipniss actually carried his love of the game that far, but the aesthetics of it certainly appealed to him and his description of it is vivid to this day.

In 1948, in Wittenberg College, Kipniss's roommate, a French exchange student named Pierre Lhomme, who later became an important cinematographer, introduced him to French films. They affected him deeply, particularly the films of Marcel Carné (1906–1996) and Jean Cocteau (1889–1963). The shadowy and anonymous urban atmosphere in such a film as Carné's *Le Quai des brumes* resonated with the young poet and painter; so too did the extraordinary surrealist imagery of *La Belle et la bête*, or the earlier and more experimental *Le Sang d'un poète* by Cocteau, himself a poet, painter, and filmmaker. However it was the sheer visual poetry of Carné's celebrated *Les Enfants du paradis* that really made an impact on him. In 1950 Kipniss transferred to the University of Iowa with the idea of becoming a poet; he also studied painting, stubbornly refusing formal instruction, as he had done in 1947 when he took classes at the Art Students League in New York. In 1951 he won a painting competition and was awarded a one-man show in New York City at the Creative Gallery on 57th Street, and a second in 1953, both of which garnered good reviews. In addition to the Lawrence Campbell review quoted earlier, a review in *The Art Digest* appeared: "With a wandering brush, Robert Kipniss paints semi-abstractions, suggesting romantic images of ethereal landscapes and half-grasped moments."[8] About

these two exhibitions, Kipniss has affirmed, "That first show, in 1951...consisted in abstractions which were mostly biomorphic suggestions of landscapes." *Intimations of the North Country* (see plate 1), painted in 1950, was just such a painting. "In 1953 I...had my second one-man show.... These paintings were of landscapes and still lifes, aggressively brushed and mostly muted and tonal. By then I realized I...needed to go my own way, whatever that would be.... The central impetus in my work has been the endless range of feelings and of thoughts evoked...by the basic act of seeing, always in isolation."[9] By the time of his second one-man show, Kipniss had begun what he described as his "lifelong pursuit of finding expression in the images of landscape and still life."[10] Although *The Poet as a Dwarf* of 1952 (fig. 2) is neither landscape nor still life, it was one of Kipniss's most unusual and perhaps personal pictures at that time. Against a background of a metal industrial window, the dwarf stands aggressively, his stature, clubfoot, and spastic hand representing, perhaps, the artist as outsider, or the frustrations of a creative mind in a hostile environment. More importantly, it is also an early indication of the intensity of emotion that drives his work.

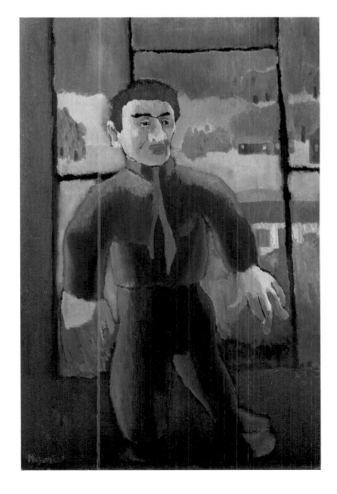

figure 2
The Poet as a Dwarf, 1952,
oil on paper, 36 × 25,
Collection of David Weigle

In 1954 Kipniss moved to New York, settling there permanently after his army discharge in 1958. He lived near Central Park on 97th Street and 5th Avenue, where he soon made a habit of sketching the trees and rocks, returning in a way to the woods to nourish his isolation and solitude as he had done as a child, and a series of paintings resulted, including *From Central Park East* of 1958 (fig. 3). He revisited the subject in 2004 in the beautiful, powerful, and surreal painting *The Balanced Rock* (see plate 80). The rock appears to be animated

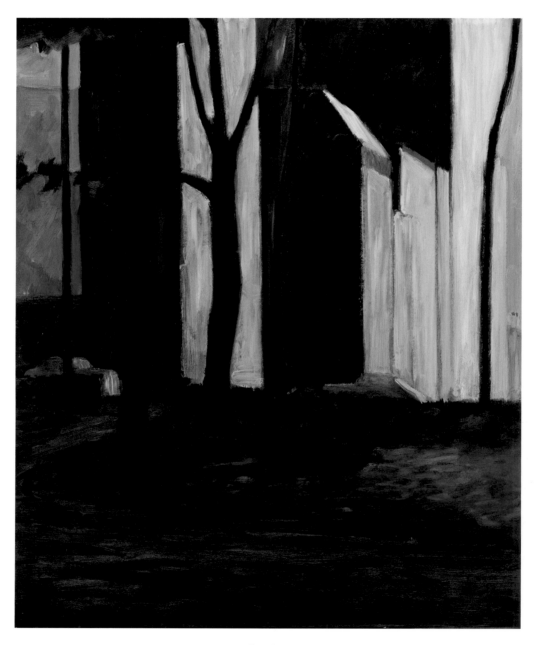

figure 3
From Central Park East, 1958,
oil on paper, 30 × 25,
Collection of David Weigle

by natural forces and in the Shinto religion of ancient Japan, it would have been encircled with a sacred rope.

In 1959 Kipniss had a job as a manager of a small bookshop, and he worked in the post office at night from 1960 to 1963, where, he recalls, "I would empty sacks of mail onto large conveyor belts."[11] The sixties were exceedingly important to him professionally. He had made the decision to stop writing poetry and he embarked upon a series of large painterly drawings, which would ultimately lead to his current style of painting. Furthermore, it was a period when he also turned to printmaking, and his work began to sell. However, it was the sudden burst of energy he poured into drawing that would change the course of his art. "Most of these drawings were done from 1960 to 1963.... In retrospect they reveal...the demarcation between *wandering* and *exploring* (author's italics).... I decided that the work was not progressing.... Impulsively, I interrupted my painting and began drawing on large sheets of paper.... I began working with a new vigor[,]...almost violently going at the surface[,]...beginning to feel as if I were working in three-dimensional space[,]...trying to reach outward spatially and inward emotionally.... Every few weeks I would...try to carry these developments into paint on canvas and indeed it began to happen." It happened in such works as *Untitled 48* (fig. 4) and *Untitled 16* (fig. 5), done in 1963, both of which reflect the "almost violence" of his exploratory drawing. "Much of what I did later grew from the making of these drawings," he once observed.[12]

figure 4
Untitled 48, 1963,
pencil, 11 1/2 × 14 1/2

figure 5
Untitled 16, 1963,
pencil, 8 3/8 × 10 3/4

If the work of the fifties and sixties was exploratory, searching, the work of the seventies and eighties was consolidating and refining, the forming of a vocabulary for the expression of his ideas. The work of the nineties to the present represents the achievement of a mature artist, the marriage of grammar, syntax, and vocabulary to fulfill the intensity of his vision; in Rilke's words, "not to form, nor to speak, but to reveal."[13]

The work of the sixties was bold and powerful, if a bit rough-edged; and, judging by some of the reviews, it definitely made an impression. "It is gravity and romance suggested by a distinctly personal feeling for nature. Objects are greatly simplified and isolated, and by a means of a monochrome of grayish green acquire a remarkable feeling of solitude," stated the *New York Herald Tribune* as early as 1960. And a critic at *Time* noted, "Robert Kipniss—in the twilight zone between recollection and imagination—has found a vista of mind and mood he calls 'the inner landscape.' With hushed tones, feathered brushing and eerie chiaroscuro... appearance of reality and the ambiance of dreams." In the *New York Times* Dore Ashton wrote, "[H]is lonely romantic vision is reminiscent of the Hudson River School painters. . . . [He] paints the chill light of early winter as it throws its mysterious shadows against tree and barn and makes them loom with singular mystery against the sky. . . . [He] knows how to suppress incidental detail in order to give greater power to his imagery."[14]

In 1983 Kipniss moved to his present apartment and studio in Ardsley-on-Hudson, New York, within walking distance of the river and the railroad station, and easy access to New York City. Previously, in 1979, he was invited by his alma mater, Wittenberg University in Springfield, Ohio, to dedicate their new art building and to receive an honorary doctorate. He was also given a one-man show of his prints, but the surprising, even revelatory, experience for him was rediscovering on the streets of Springfield the subjects of current paintings on which he was then working. It was only then that he realized that the genesis of these paintings was buried in the past, recollections of the landscapes he had experienced in his college days some thirty years before, when he took long, solitary walks in the evening hours. He remembered in particular the alleys, called service alleys, that ran behind blocks of small houses. This experience evokes the Rilke poems *Initiation* (*Eingang*)—"Whoever you are, go out into the evening"—and *Memory* (*Erinnerung*)—"you remember lands you have wandered through. . ./And you suddenly know it was here!"[15] Kipniss had spent many hours walking and thinking in those alleys and afterwards made sketches of them from memory. As he once said, "the elements that would remain a large

part of my imagery all my working life began to emerge in these sketches." They had become part of his vocabulary and, once again, well into the nineties, he made return trips to sketch and draw those alleys and the surrounding area. The extraordinary still and wintry 2005 painting *Springfield, O. III* (see plate 95), imbued with solitude and silence, is derived from a sketch of the same name drawn in 1998 (fig. 6). However, despite the reference to a specific place, that place was (and is) used only as a starting point for a very private and intense emotional response, part of his personal journey through a combination of recollection and imagination that is the essence of his art.

Kipniss's art is not the art of the explicit, the instantly recognizable. His is not an art of a modern practitioner of Hudson River School painting, replete with its quiet observation of fact and lovingly painted incidental detail; neither is there the fleeting scene glimpsed from a window that prompts the response, "Ah, another perfect Kipniss." That kind of response is elicited more by the transfor-

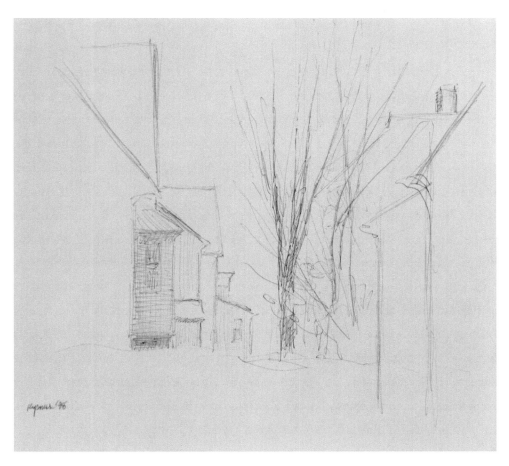

figure 6
Springfield, O. III, 1998,
pencil, 6 3/4 × 7 1/2,
A private collection

mation of his subject through his unique style, than by any mimetic quality in the work.[16] Whether that subject is a still life, an interior, Central Park, the alleys of Springfield, Ohio, or the landscapes of the northwest corner of Connecticut, which he began visiting in the early nineties, it is treated with ambiguity and the equivocal. Often such painting titles as *Sharon, Connecticut* or *Millerton, New York*, if not meaningless, are certainly not descriptive.[17] In transforming the elements of a place from the specific to the generic, trees, fences, houses, hills, and roads become simultaneously familiar and unfamiliar, as in a dream, or as *Time* magazine put it, "in the twilight zone between recollection and imagination." Even a more specific work such as the 1999 *Little Compton* (see plate 45) is Hopperesque in its abstraction and isolation. Kipniss's work often presents itself as a friend when seen at a distance, yet on closer inspection, turns out to be a stranger after all.

It is a stranger who is, nevertheless, fascinating and draws the viewer into the world of the painting, a world that is, by turns, mysterious yet elegant; reassuring yet unsettling; silent and serious; inviting yet detached; strong and delicate; complex yet simple. These "symbolic pictorial complexities" are not unlike those of the poet Rainer Maria Rilke, or perhaps of the Romantic nineteenth-century German landscape painter Caspar David Friedrich (1774–1840). But a more interesting example might conceivably be Tonalism, the turn-of-the-nineteenth-century American style "that was concerned with emotion, mood, conceptual truth and the reality beyond appearances, not the transcription or objective rendering of nature." These were artists, primarily landscapists, whose conceptions were driven not by color, but by tone—or the black-and-white value of what was often a single color, subtly handled, as in the work of Birge Harrison (1854–1929) or James McNeill Whistler (1834–1903). Like Kipniss's paintings, "their canvases were studio productions done from memory with the aid of sketches." And also like Kipniss, Tonalist painters only "include evidence of human presence seen in a clearing, fence, or path, but are not concerned with activity in and of itself."[18] Yet these similarities, however interesting, can be superficial. Tonalism was very much of its time, part of the "genteel tradition" in American life, and Kipniss is very much a part of his own time—not a quiet observation of fact, but a quiet intensity of emotion.

All of this raises the issue of influences, especially in the work of an artist who adamantly refused formal instruction in either the art of poetry or the art of painting. Influence means "flowing in," and despite a tenacious grip on independence, there are those correspondences or kinships with artists whom Kipniss admires. Art does flow from emotion, from intelligence, and from experience, of

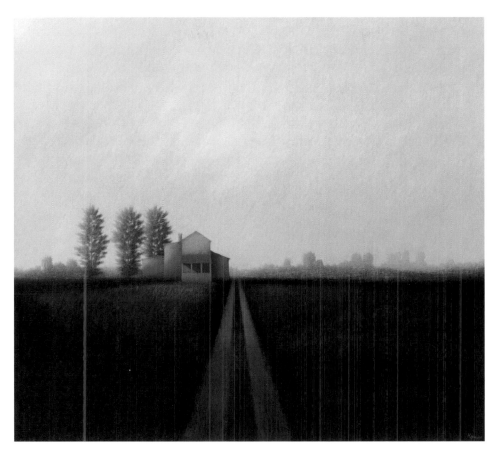

course, but also from other art. Was he a borrower? If so, it was either subconsciously (he was not *that* aware of Tonalism, for example), or it was thoroughly assimilated, or it was coincidental. Perhaps the word "borrow" might not be appropriate. Perhaps "inspiration" might be more accurate. One idea starts another and it is often hard to say where the credit lies. Kipniss was impressed by Nicolas de Stael (1914–1955) for his attempted balance of abstraction and figuration, but their work is nowhere near alike. In Kipniss's drawings and mezzotints there are echoes of the drawings of Georges Seurat (1859–1891)—the drawings for *Bathers at Asnières* of 1884 (Tate Gallery, London), for example, a painting Kipniss especially admires—and in his still lifes there is a kinship with Giorgio Morandi (1890–1964) in such paintings as *Still Life with White Kettle* of 1998 (see plate 40), or *Still Life with Glass and Cup* of 2004 (see plate 83). Kipniss admires Cézanne's handling of paint, as well as the haunting qualities in the work of such Surrealist artists as Yves Tanguy (1900–1955), the late work of René Magritte (1898–1967), and, as mentioned before, the films of Jean Cocteau

and Marcel Carné. In Kipniss's painting *Three Trees and Roadside* (fig. 7), done between 1992 and 1997, a far-reaching surrealist perspective is used as much for emotional depth as for virtual distance; *Interior with Chair and Standing Lamp* of 2000 (see plate 53) has the weird and cinematic effect of a Cocteau work and *The Artist's Studio* (see plate 44), done in 1999, has an uncanny similarity to Magritte's 1933 painting *La Condition humaine* (National Gallery of Art, Washington, D.C.). Some characteristics of the latter do appear in his work where—in his uninhabited landscapes and in the stillness of his still lifes—solitude and silence, mystery, and perhaps even alienation are present to a greater or lesser degree. Human presence is indicated by objects that are both familiar and unfamiliar, and by the assumption that the viewer is quietly looking on—observing. These characteristics are transformed by the intensity of his purpose and the independence of his thinking into a highly individual style, combined with a single-minded immersion in his art and in the methods by which he brings it to life.

In the fifties Kipniss would get his ideas while on long walks, in the sixties he sketched in Central Park and made large drawings in the studio, and in the seventies he did both. In the eighties, as mentioned before, he began making return trips to Springfield, Ohio. He would go back just to sketch. In the nineties he sketched in Connecticut on site, but he continued to draw from imagination. Now he observes, interprets, makes up. For example, *Branches near Sharon* (see plate 101), a painting of 2005, is based on a drawing of 1962 (fig. 8), but has nothing to do with place. He gets many of his ideas sketching from his imagination in the evening. If he sees something he likes, he takes it further and it may or may not end up as a painting. His general themes are the exploration of spatial and volume relationships. He is never aware of working on a flat canvas, but sees himself entering the space in the same way that in Cocteau's film *Orpheus* the hero enters the space behind the mirror. Inside his mind he starts with the foreground as an entry and works his way to the back of the canvas, as he attempts to "discover the world as he creates it."

Like the French painter Fernand Léger (1881–1955), Kipniss allows nothing to disturb his routine—up very early for a session at the gym, then breakfast, then to his studio, rain or shine, where he will spend all day, every day, very much like a workman, or a craftsman.[19] Upon entering his studio (what was a one-bedroom apartment) and leaving a short hallway, past a bookcase of shelf after shelf of poetry, there is a long north wall with windows and a pleasant view outside. However, the blinds are tightly drawn, emitting a dim halftone of light, reinforcing the atmosphere of a sanctuary somewhat reminiscent of Albrecht

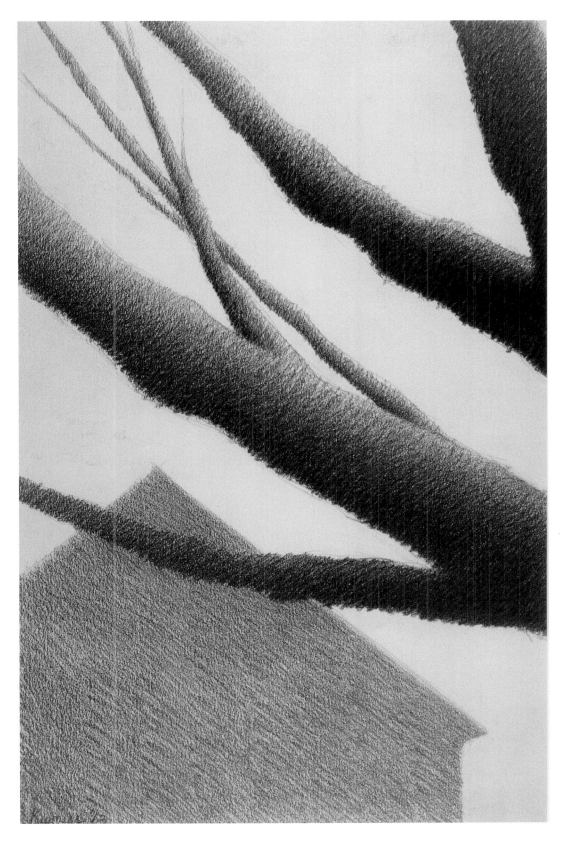

figure 8
Branches, 1962,
pencil, 20 × 13

Dürer's great engraving *St. Jerome in his Study* (1514). The only light source comes from a 125-watt flood, illuminating the easel standing in front of the east wall, an easel that he has owned since he was nineteen. To the left of the easel stands a table that holds his palette, brushes, and turpentine. His palette generally consists of only eight pigments: raw umber, ivory black, Naples yellow light, terra verte, cobalt green, Windsor green, Windsor blue, and titanium white. Lately his darks have become less dark, more transparent and more in a middle tone—umber mixed with black, blue, and a little white. He uses disposable paper palettes and small flat-bristle brushes ranging from 1/8 to 3/4 inches wide. Kipniss prefers to work in artificial light, which is not unlike that used to illuminate a pool or billiard table. He prefers artificial light to daylight because it approximates the conditions under which his work will be viewed in a gallery. It is a hermetic, private, and personal world to start with, a world which is very much reflected in his art.

He starts by sitting on the sofa (his only concession to personal comfort), facing his easel and studying for twenty or thirty minutes the two or three paintings he has in progress in order to decide which of those paintings he needs to work on first. In short, Kipniss is an artist who gives a lot of thought to his painting, almost as though echoing René Magritte's statement, "The act of painting is an act of thinking."[20] He will work until 1:00 p.m., when he has lunch with his wife, after which he is back in his studio from 2:00 p.m. until 6:30 or 7:00 p.m., except when he needs to finish a particular section of the canvas. Then he will stay later—until 8:00 or 8:30 p.m. If all of this sounds terribly matter of fact, it certainly is not. At the very least, it is passion organized: Robert Kipniss simply loves to paint.

In Kipniss's process "there are no short cuts" and "the difficulty of making the work [is] more intense than the success in its reception and sales." He immerses himself totally in his painting and is intensely single-minded, or, as he says, "selfish" about it.[21]

His technique is laborious and precise, and he uses no medium, just the pigment straight from the tube. He starts with a drawing and sometimes a small painting. And he sometimes lets a drawing sit for several years before it becomes a finished painting. For instance, a pencil study for *Interior with Window and Pot* (fig. 9), done in 2000, did not become a finished painting until 2005 (see plate 93); yet the pencil study for *Still Life with Two Vases* of 2002 (fig. 10) became a completed oil in the same year (see plate 69). When the subject is defined and arrived at in the sketch or small painting, Kipniss has to decide on the stages and in doing so he approaches it obliquely, spending a great deal of

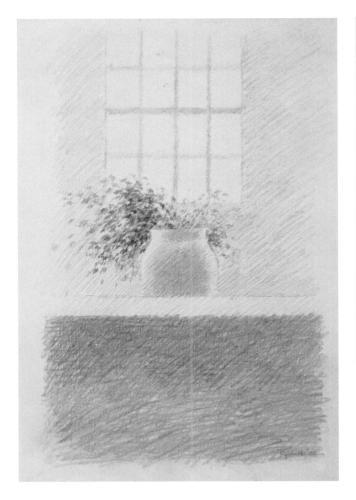

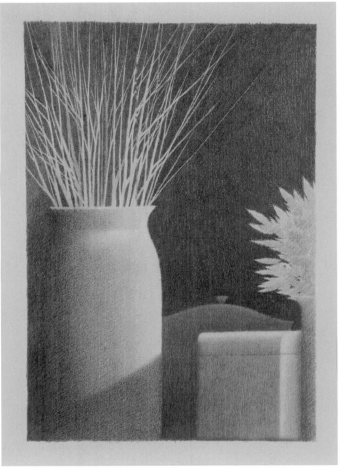

figure 9
Interior with Window and Pot, 2000,
pencil, 10³⁄₈ × 7

figure 10
Still Life with Two Vases, 2002,
pencil, 12³⁄₄ × 8³⁄₄
Collection of Henry and Nancy Schacht

time thinking and planning as he marshals all his energy to a given end. Even his extemporized paintings, such as *Lace II* (fig. 11), *Trees* (see plate 68), and *Summer Evening* (see plate 52), for which there are no sketches or drawings, take two and a half to three weeks to do. Sometimes Kipniss will take up the same image and, with some adjustment, use it in another medium. The pencil study for *Presentation: Trees* in 1999 (fig. 12) became an oil painting in 2004 (see plate 89) and a mezzotint, *Apparition II*, in 2005 (fig. 13). His actual painting method is as follows:

1. He starts with an undercoat of gray on the canvas.

2. In the initial lay-in, he starts with a medium dark tone for the positive shapes.

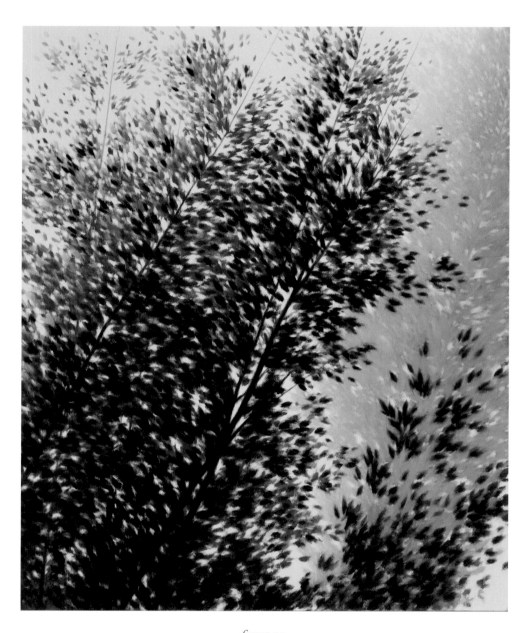

figure 11
Lace II, 2003,
oil on paper, 24 × 20,
A private collection

3. He mixes a light tone for the negative shape.

4. As the painting progresses, he works a day or two in the positive shapes, then a day or two in the negative, alternating between them until he is satisfied with a taut balance, wherein the negatives are not just what the positive doesn't occupy, but are an equal presence. At this point he has a fully realized and finished work.

figure 12
Presentation: Trees, 1999,
pencil, 11 × 8 ½,
Collection of the artist

5. He lets the painting dry thoroughly and he applies retouch varnish to
 bring up the pigments that have "sunk."

Obviously the development of a Kipniss painting is not as simple or so dry as
outlined above. The physical process might appear to be prosaic, but the out-
come is pure poetry. The solitude of his landscapes and the silence of his still lifes

figure 13
Apparition II, 2005,
mezzotint, 10¹/8 × 9³/8,

are imbued with a feeling of the poetic that belies the workmanlike process by which they are made.

The factors that propel an artist and lead to what Kipniss calls a "signature style" are many and varied. In his case, perhaps the most significant are his need for solitude and privacy represented by the imagery of trees; his experience of the streets and alleys of Springfield, Ohio; his introduction to French films; the prominence of draftsmanship and his passion for it. Most important is the intensity of emotion with which he invests each and every painting. Yet because Kipniss makes his art seem so effortless, at first glance it is not always possible to feel that intensity. It requires a commitment of concentration and focus on the part of the viewer (as it did on the part of the artist), an effort amply repaid

when the full meaning of the painting reveals itself. Finally there is Kipniss's love of poetry, especially that of Rainer Maria Rilke. Kipniss's poetry is no longer written but visual, yet in its solitude and silence it shares a spiritual kinship with the poetry of Rilke, such as *Memory*, quoted above, or the great German poet's remarkable and moving *Solitude* (*Einsamkeit*), which reads in part:

> "Die Einsamkeit ist wie ein Regen. . . .
> Regnet hernieder in den Zwitterstunden,
> Wenn sich nach Morgen wenden alle Gassen. . . .
> Dann geht die Einsamkeit mit dem Flussen."

> "Solitude is like a rain. . . .
> It falls like rain in that gray doubtful hour
> When all the streets are turning towards the dawn. . . .
> Then solitude flows onward with the rivers. . ."[22]

RICHARD J. BOYLE
Salisbury, Connecticut, 2006

Notes

The information for this essay was based upon three studio interviews; telephone conversations; the writing of Robert Kipniss, as well as writing about him. My thanks to Robert Kipniss for his unlimited patience. RJB

1. Lawrence Campbell, *ArtNews* 52:6 (October 1953)

2. *The Selected Poems of Rainer Maria Rilke*, with English translations by C. F. MacIntyre, a preface by Harry T. Moore, and lithographs by Robert Kipniss (New York: The Limited Editions Club, 1981)

3. See Monroe Wheeler, *Modern Painters and Sculptors as Illustrators* (New York, 1947); see also David Shapiro, *Poets & Painters* (Denver: Denver Art Museum, 1979).

4. Quoted in the exhibition brochure, Harmon-Meek Gallery, 1999, n.p.

5. *The Selected Poems of Rainer Maria Rilke*, 15.

6. Exhibition brochure, Harmon-Meek Gallery, 1999.

7. Mercedes Matter, "Introduction," *The Orchestration of Color: The Paintings of Arthur B. Carles* (New York: Hollis Taggart Galleries, 2000), 20: "Throughout his life, he was an expert at billiards, even able to hold his own against world champion Willie Hoppe." "…billiards reflected a deliberate effort to transform his passion and sensibility, to distill emotion through the process of painting—creating order and clarity and bringing a painting to completion."

8. *The Art Digest* 26:1 (1 October 1951)

9. *Robert Kipniss* (New York: Beadleston Galleries, 2001), 2–3.

10. Studio interview with author, 4 November 2005.

11. Ibid.

12. Robert Kipniss, *Robert Kipniss – Transitions: Drawings, 1960–1964* (Houston: Gerhard Wurzer Gallery and Tyler Museum of Art, 1999), 3.

13. *The Selected Poems of Rainer Maria Rilke*, quoted in the translator's Introduction, xxiv.

14. The quote from what was once fondly called "The Trib" was from 10 December 1960; the two subsequent statements were quoted from the FAR catalogue of October/November, 1968, unpaginated.

15. *The Selected Poems of Rainer Maria Rilke*, 3; 23.

16. Ed McCormack, "Robert Kipniss: An American Master at Half-Century Mark," *Robert Kipniss: Taking Time* (San Francisco: Weinstein Gallery, 2001), 9.

17. Studio interview with author, 13 January 2006.

18. Quoted in Ralph Sessions, "Introduction," Ralph Sessions et al., *The Poetic*

Vision: American Tonalism (New York: Spanierman Gallery, 2005), 9–10; see also William H. Gerdts, "American Tonalism: an Artistic Overview," in the same publication, 15–28.

19. See Katherine Kuh, *My Love Affair with Modern Art: Behind the Scenes with a Legendary Curator*, edited and compiled by Avis Berman (New York: Arcade Publishing, 2006), 98–99.

20. Quoted in Mary Dempsey, *The Essential Encyclopedic Guide to Modern Art* (London: Thames and Hudson, 2002), 161.

21. Studio interview with author, 4 November 2005.

22. *The Selected Poems of Rainer Maria Rilke*, 18–19.

The Plates

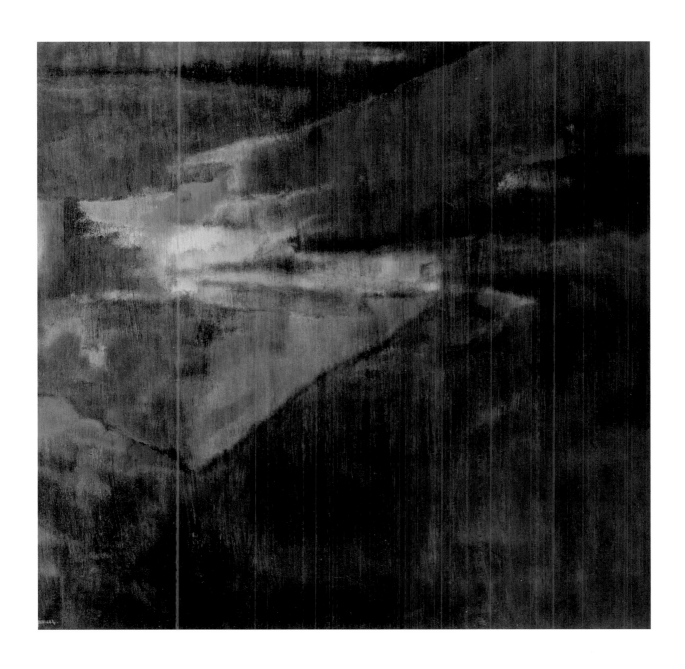

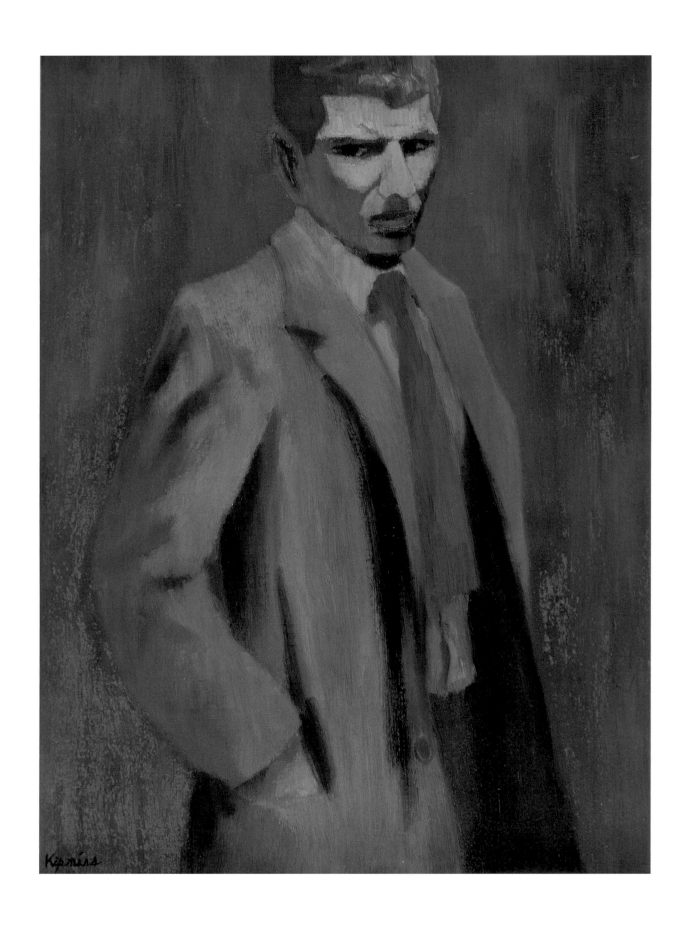

PLATE 2
Self-portrait, 1953
oil on panel, 24 × 18

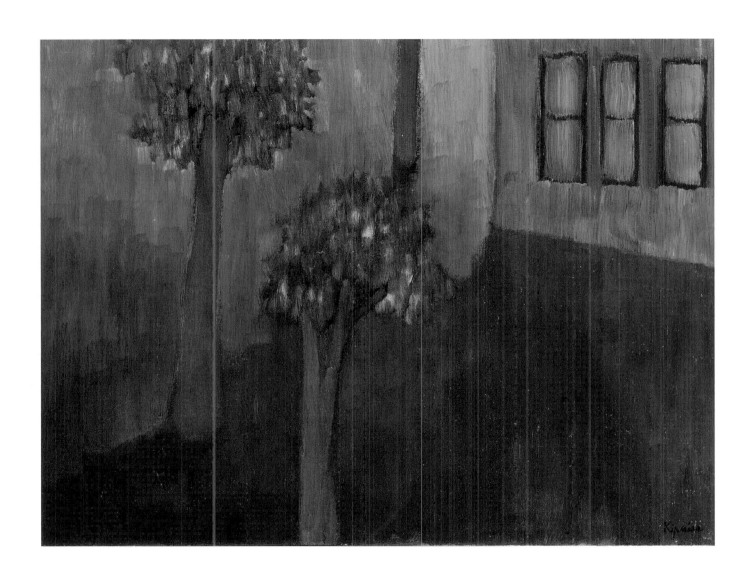

PLATE 3
Red Grass, 1955
oil on panel, 18 × 24

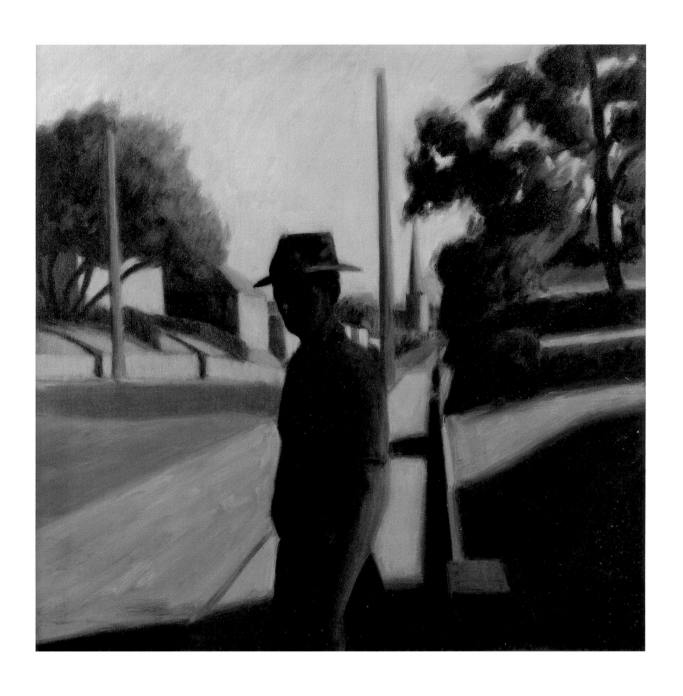

PLATE 4
Self-portrait: Petersburg, Virginia, 1957
oil on canvas, 24 × 24

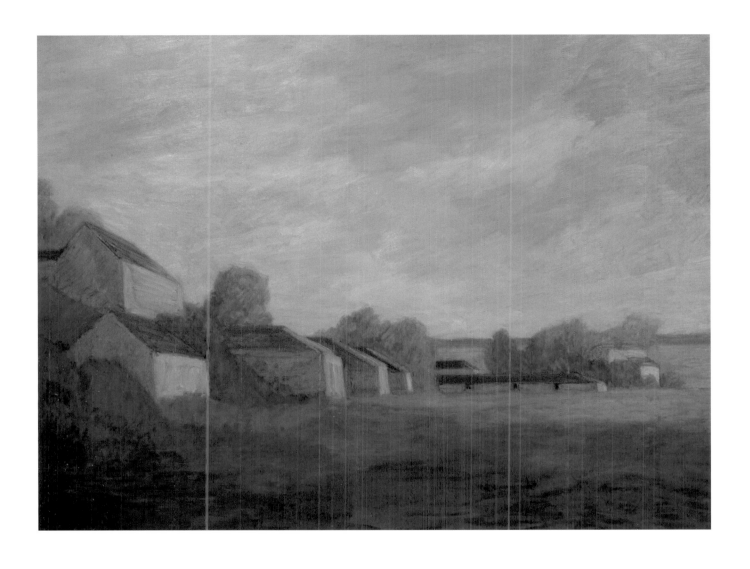

PLATE 5
Green Trees in Virginia, 1958
oil on panel, 30 × 40

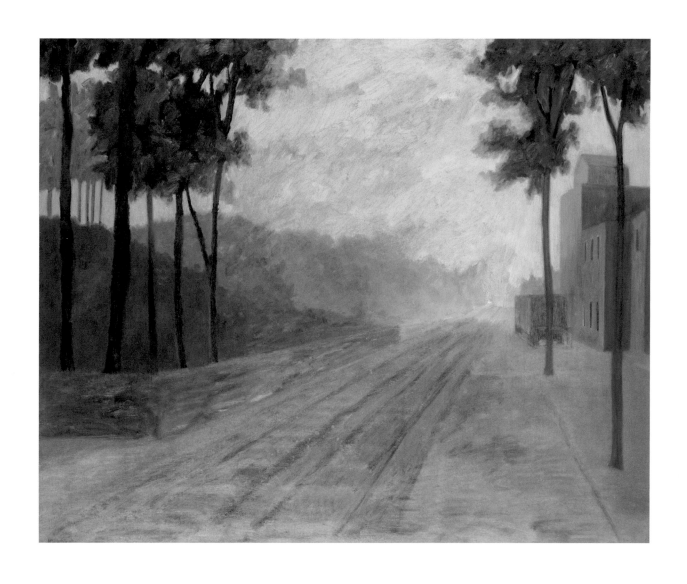

PLATE 6
Freight Spur, 1958
oil on panel, 27 × 32¼

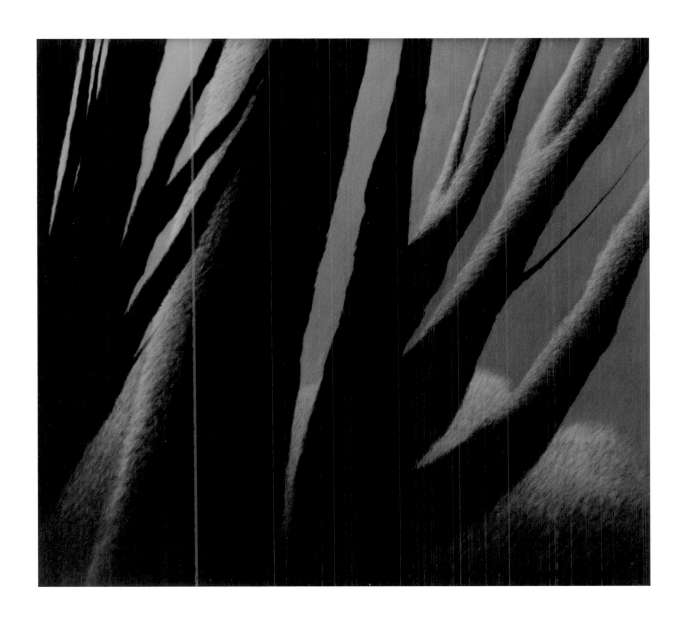

PLATE 7
Large Trees at Dusk, 1962
oil on canvas, 36 × 40

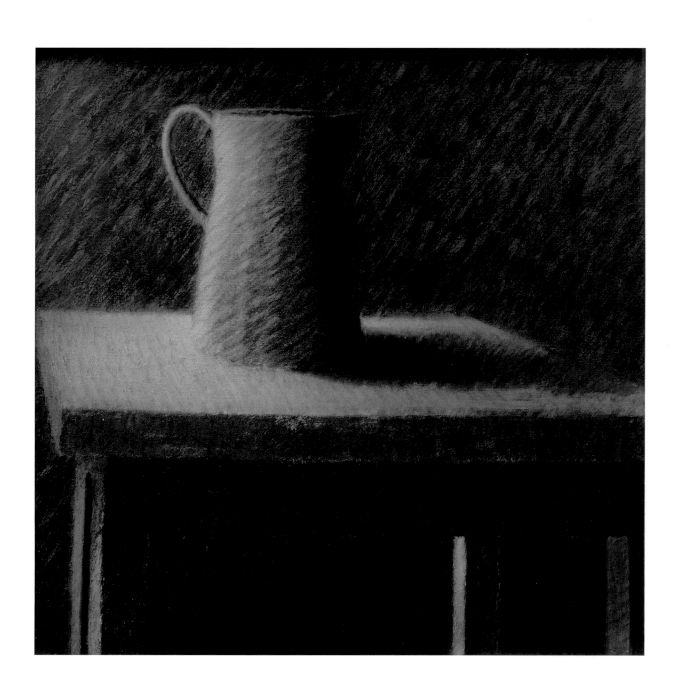

PLATE 8
Table with Pitcher, 1964
oil on canvas, 24 × 24

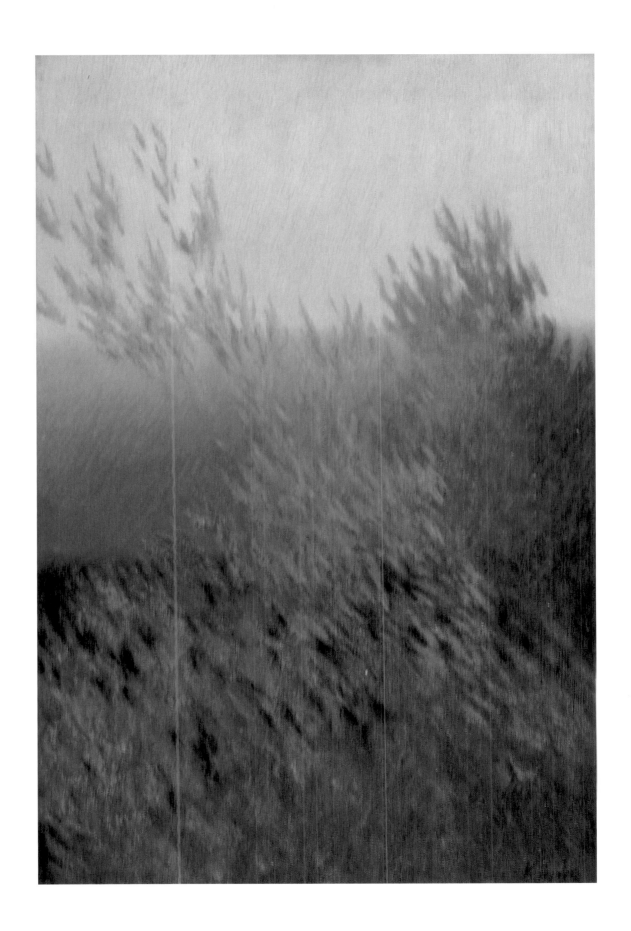

PLATE 9
Leaves and Trees, 1965
oil on canvas, 24 × 16

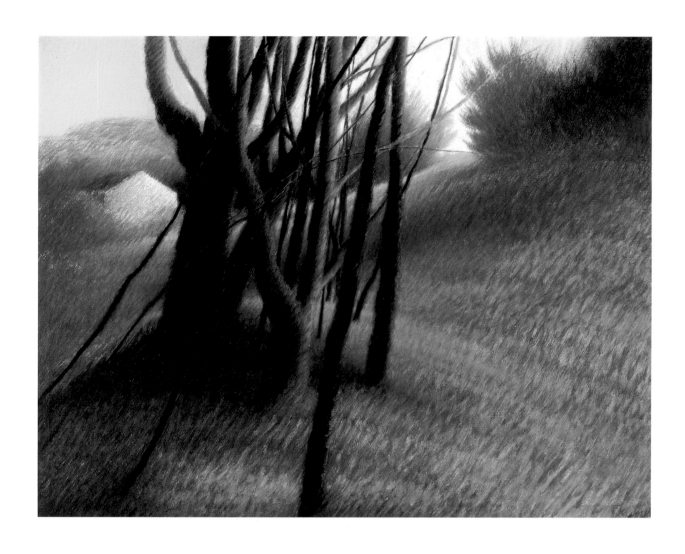

PLATE 10
Hillside, Ohio, 1966
oil on canvas, 40 × 48

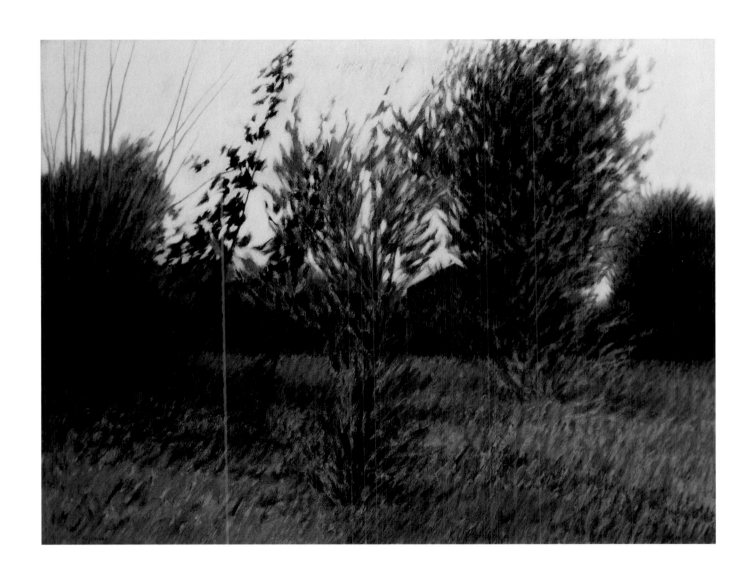

PLATE 11

Ohio Memories, 1967

oil on canvas, 30¼ × 40½

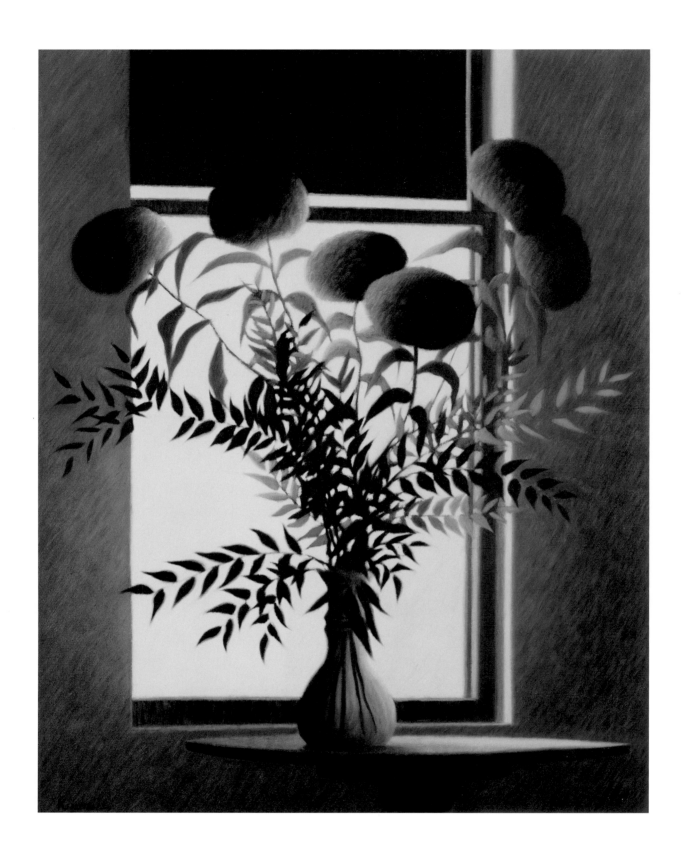

PLATE 12
Window with Flowers, 1968
oil on canvas, 38 × 30

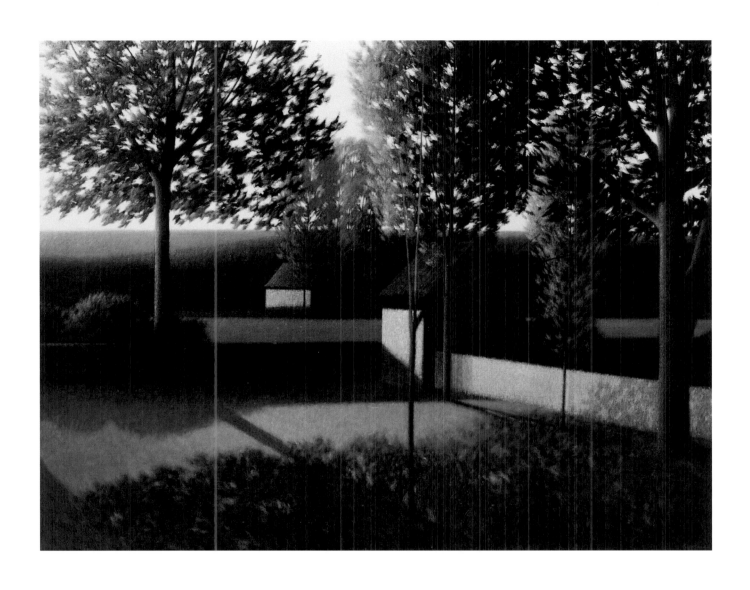

PLATE 13
Backyard II, 1971
oil on canvas, 36 × 48

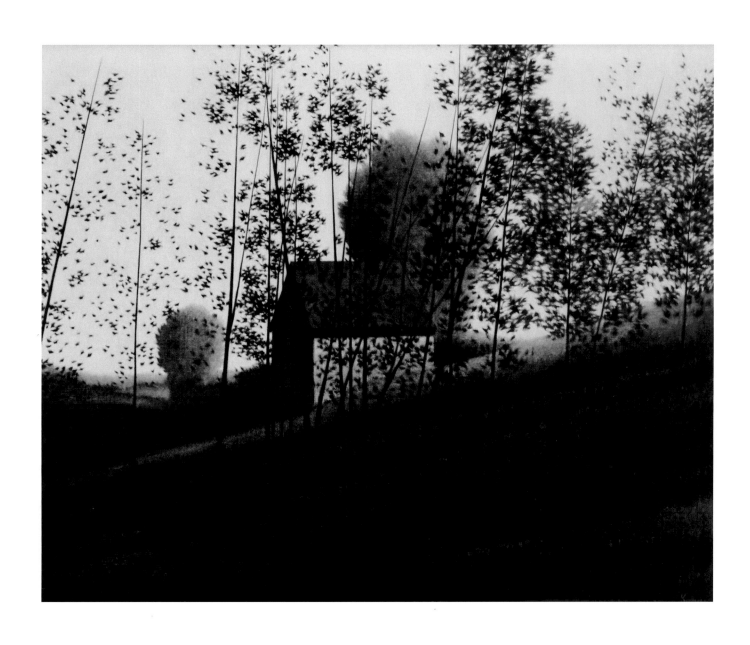

PLATE 14

Secrets, 1978

oil on canvas, 30 × 36

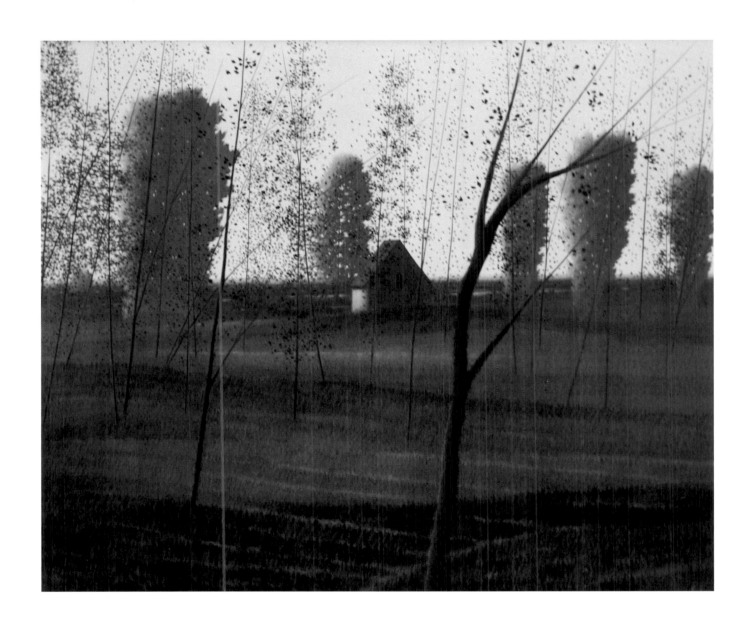

PLATE 15
Spring Secrets, 1981
oil on canvas, 40 × 48

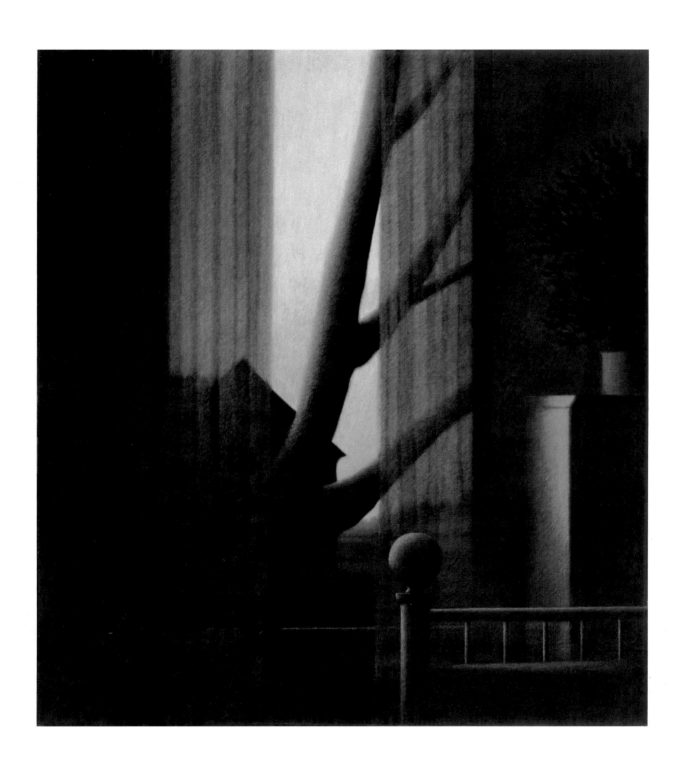

PLATE 16
Through Bedroom Curtains, 1981
oil on canvas, 40 × 36

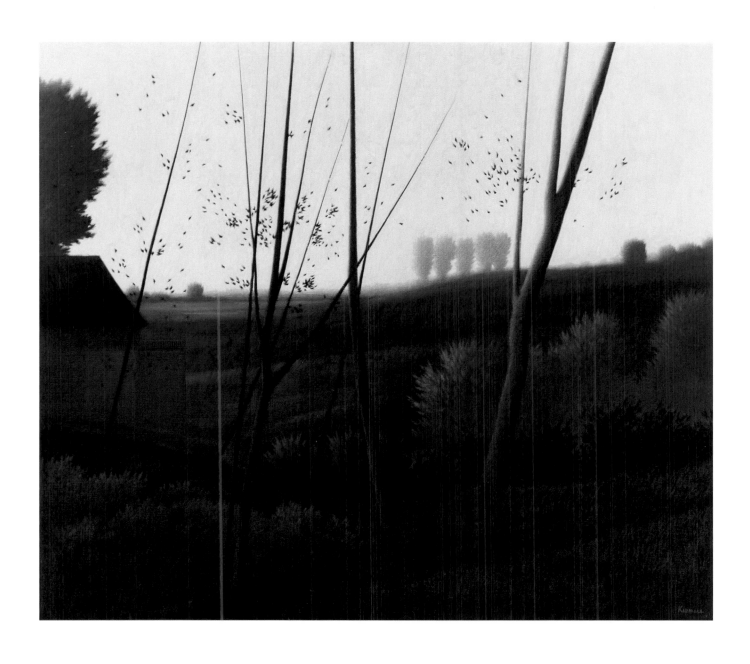

PLATE 17
Untitled #2, 1983–1994
oil on canvas, 34 × 40

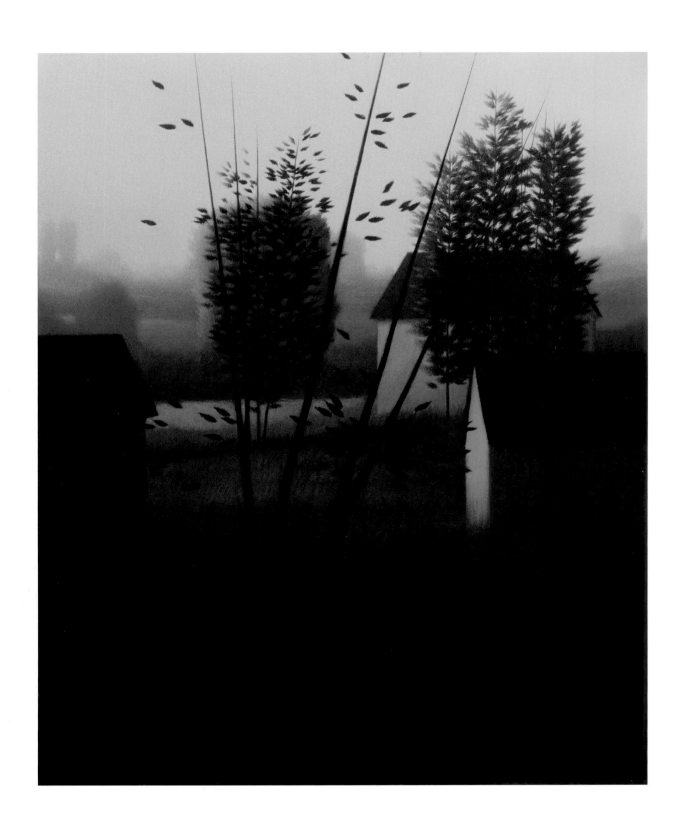

PLATE 18
Landscape with Three Houses, 1986
oil on canvas, 32 × 27

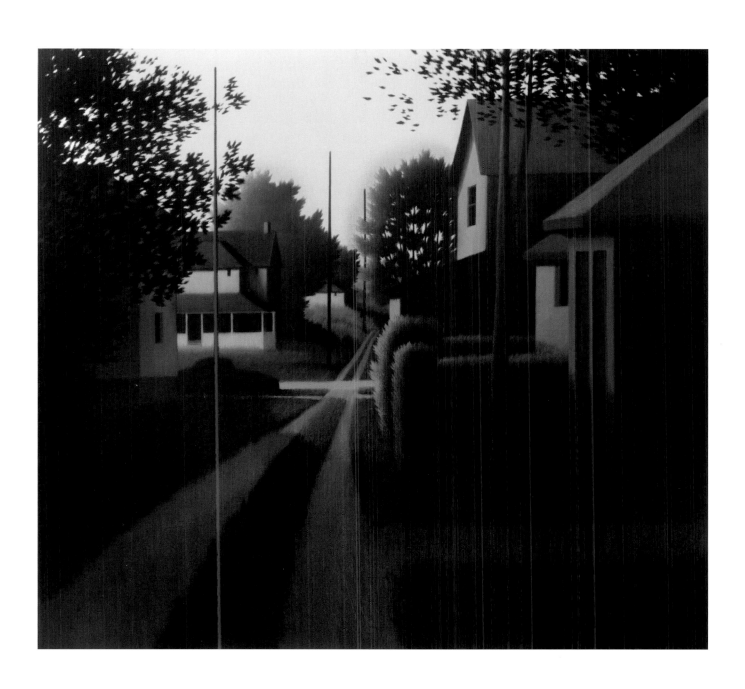

PLATE 19
Alleys, Springfield, 1986
oil on canvas, 36 × 40

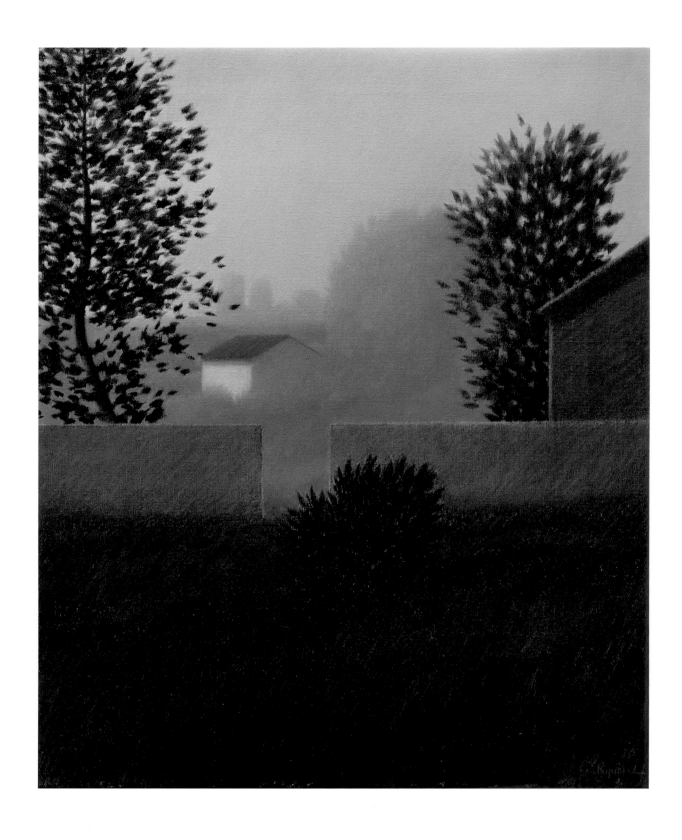

PLATE 20
Landscape with Entrance, 1986
oil on canvas, 24 × 20

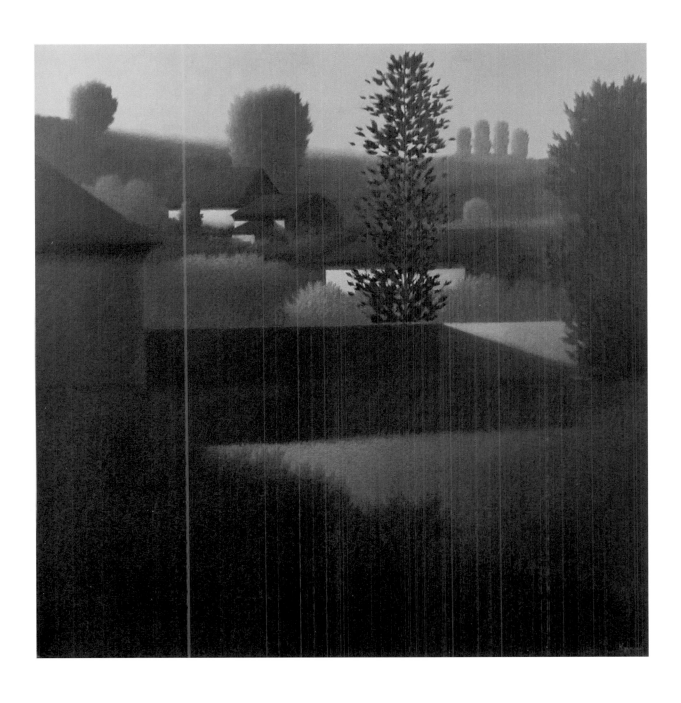

PLATE 21
Neighbors, 1987
oil on canvas, 41 × 41

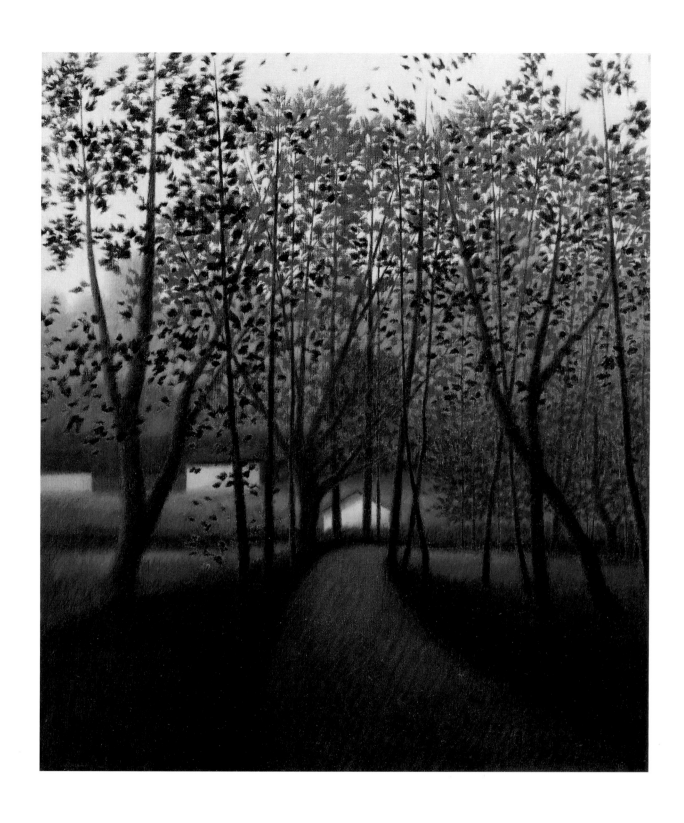

PLATE 22
Road to Middleburgh, 1987
oil on canvas, 24 × 20

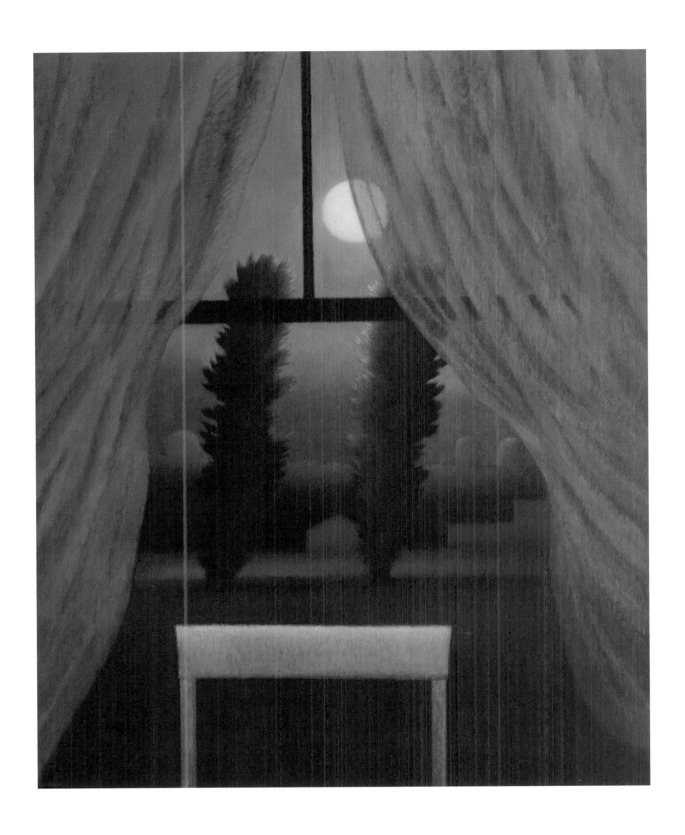

PLATE 23
The White Chair, 1991
oil on canvas, 48 × 40

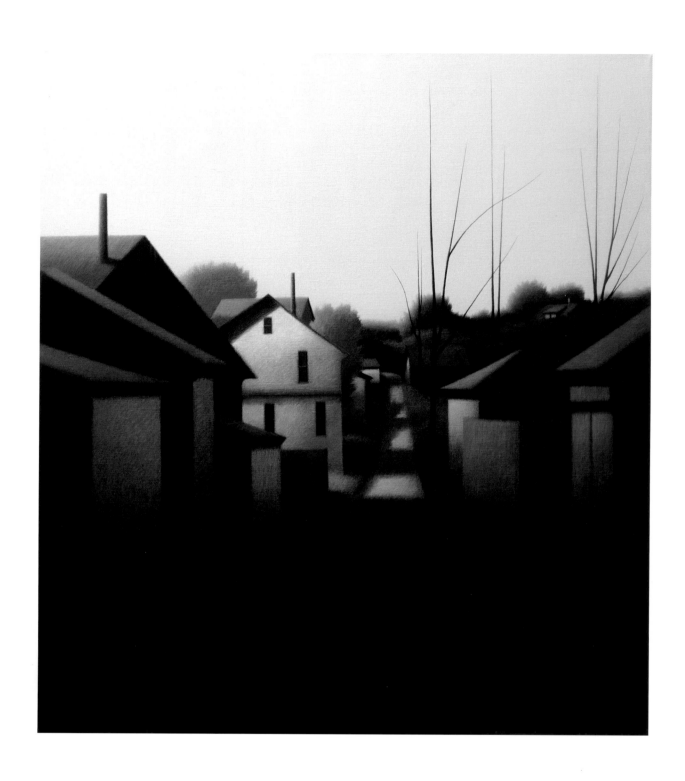

PLATE 24

Springfield, O., 1991

oil on canvas, 40 × 36

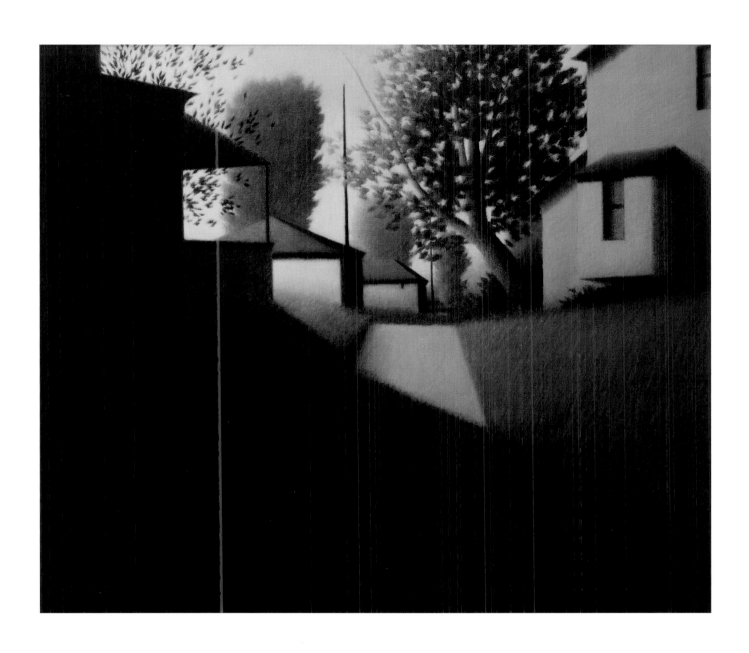

PLATE 25
Shadowed Path, 1992
oil on canvas, 26¾ × 31½

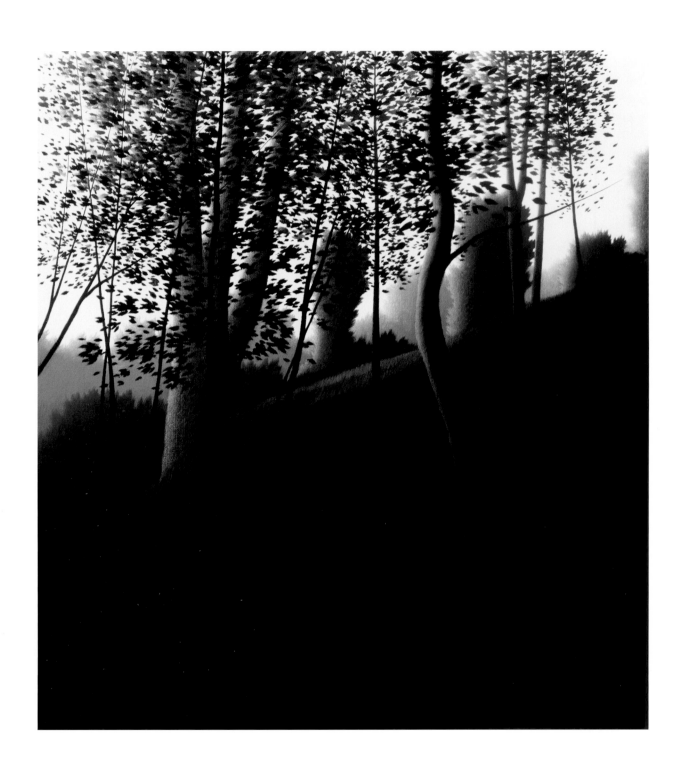

PLATE 26

Hillside, 1994

oil on canvas, 40 × 36

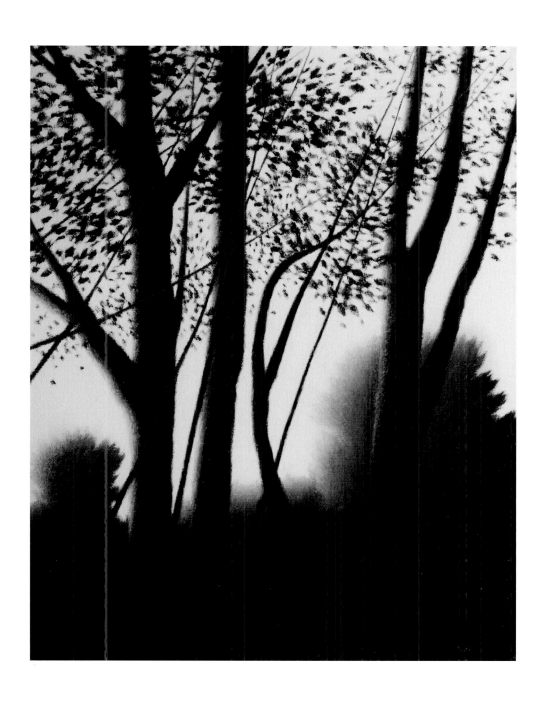

PLATE 27
Central Park, 1995
oil on canvas, 14 × 11

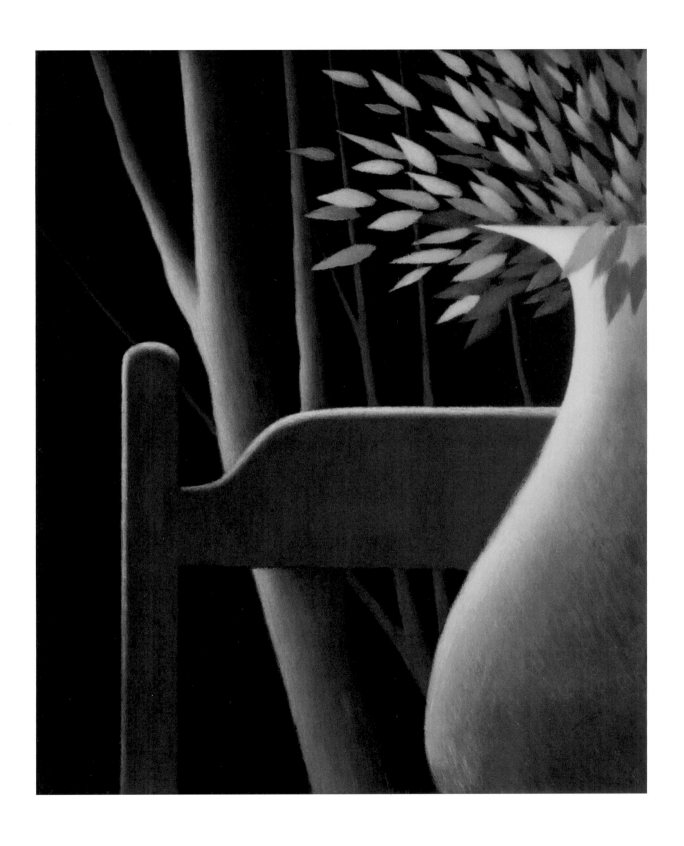

PLATE 28
Vase, Chair, and Leaves, 1995
oil on panel, 20 × 16

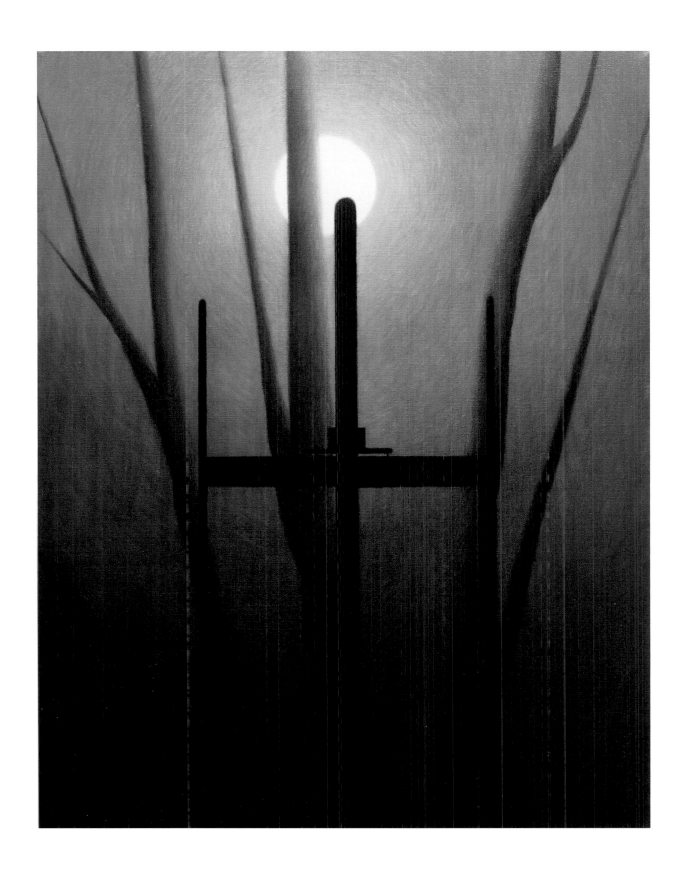

PLATE 29
Easel with Trees and Moon, 1995
oil on canvas, 27¾ × 22

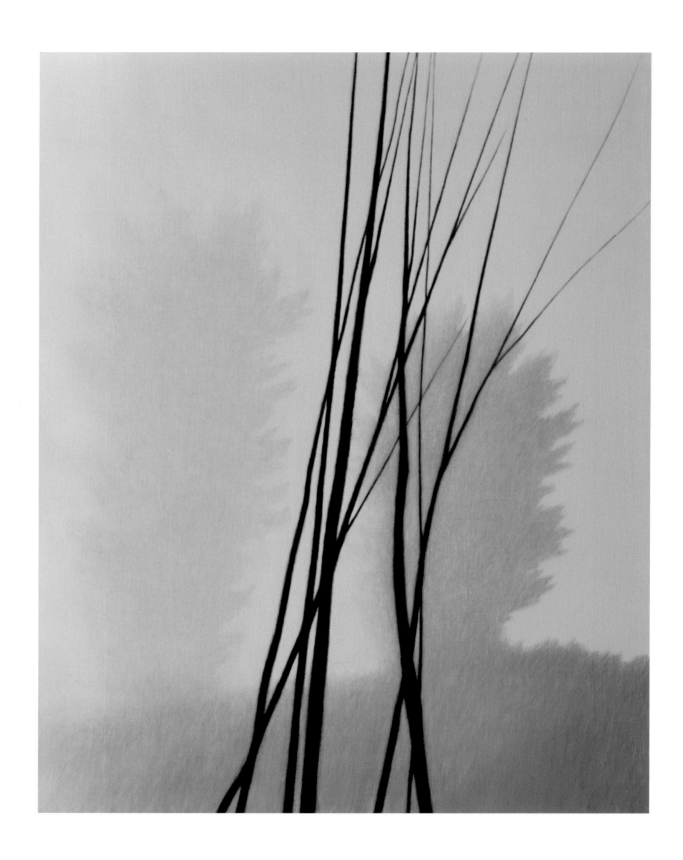

PLATE 30
Composition: Trees, 1995
oil on canvas, 20 × 16

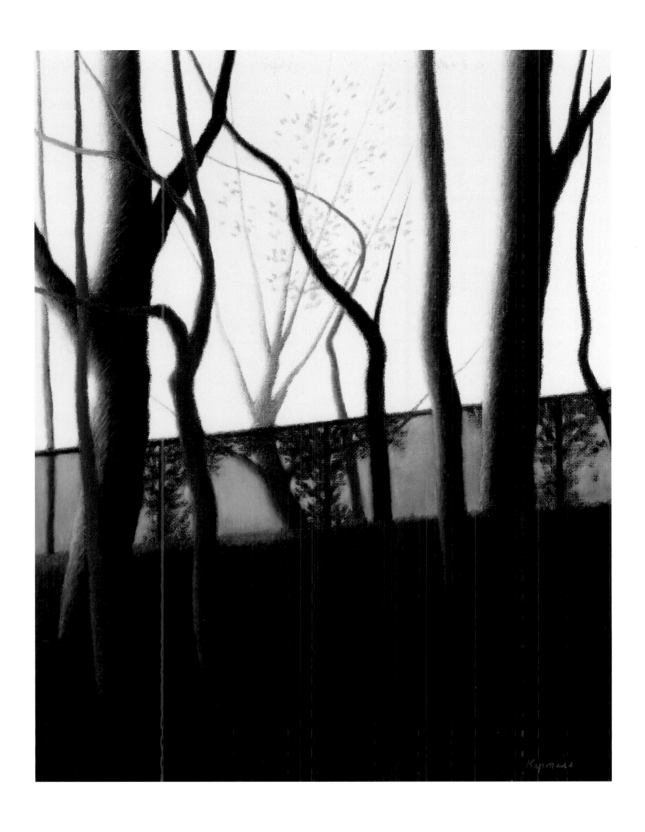

PLATE 31
Central Park: Toward the Reservoir, 1995
oil on canvas, 14 × 11

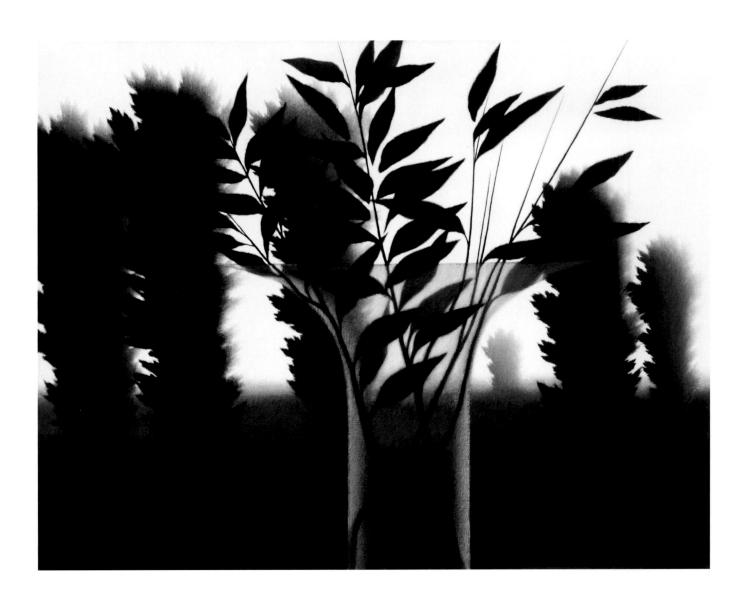

PLATE 32
Clear Vase and Landscape, 1995
oil on canvas, 22 × 28

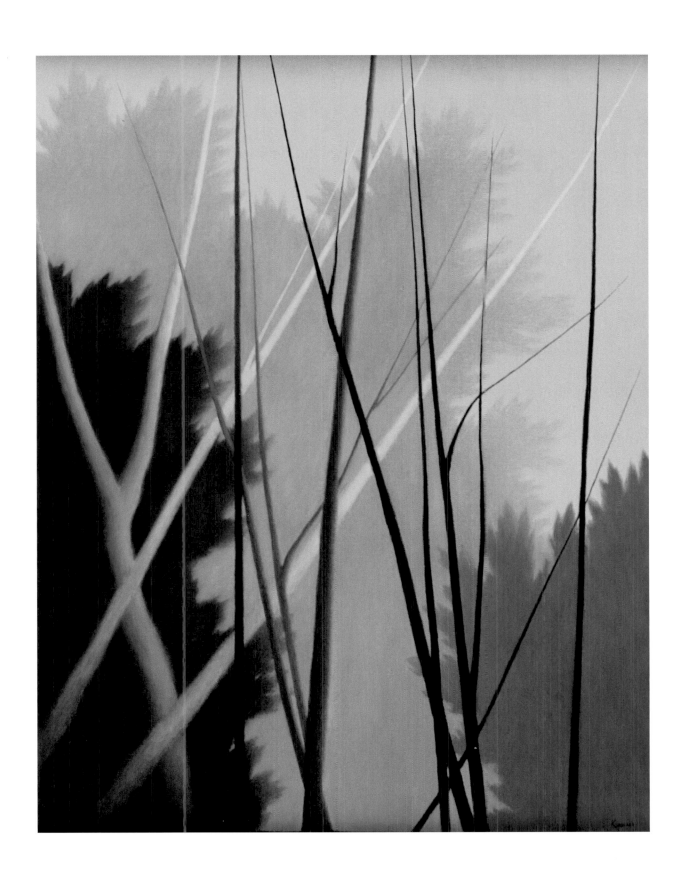

PLATE 33
Trees and Trees, 1996
oil on canvas, 28 × 22

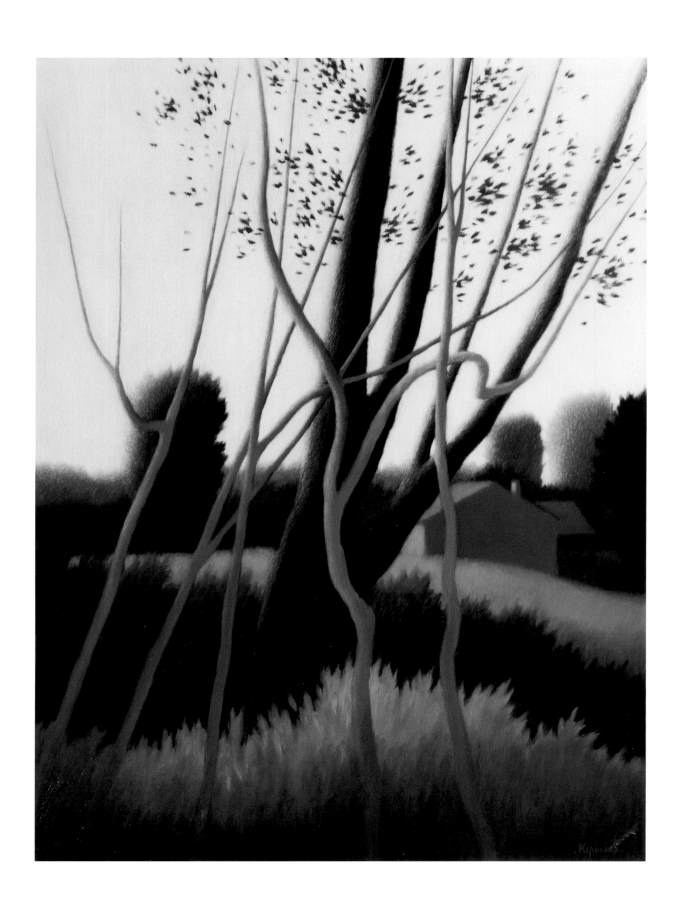

PLATE 34
Looking Through II, 1996
oil on panel, 16 × 12

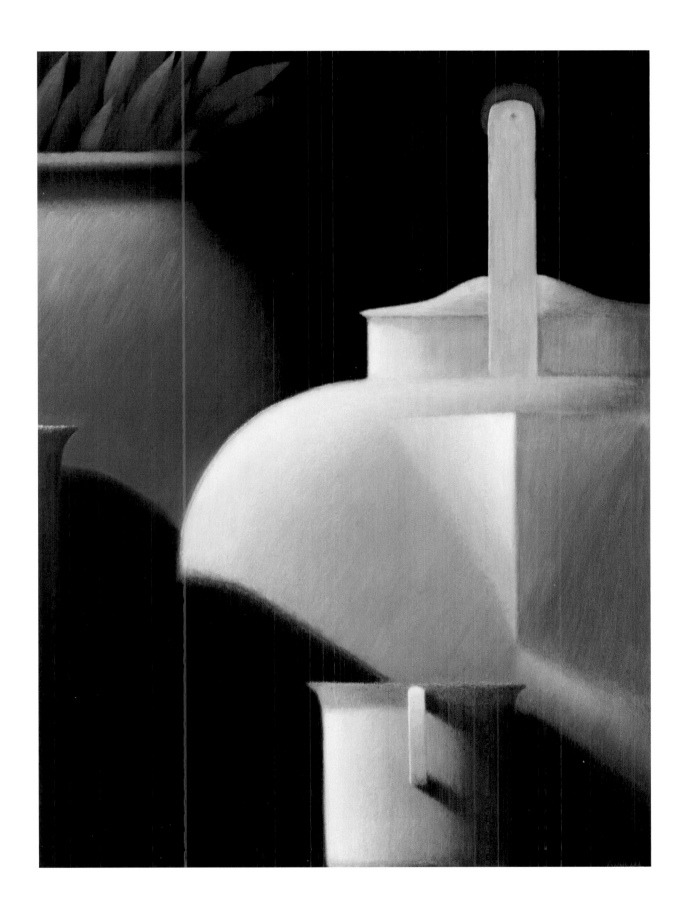

PLATE 35
Still Life with Kettle and Cup, 1997
oil on canvas, 24 × 18

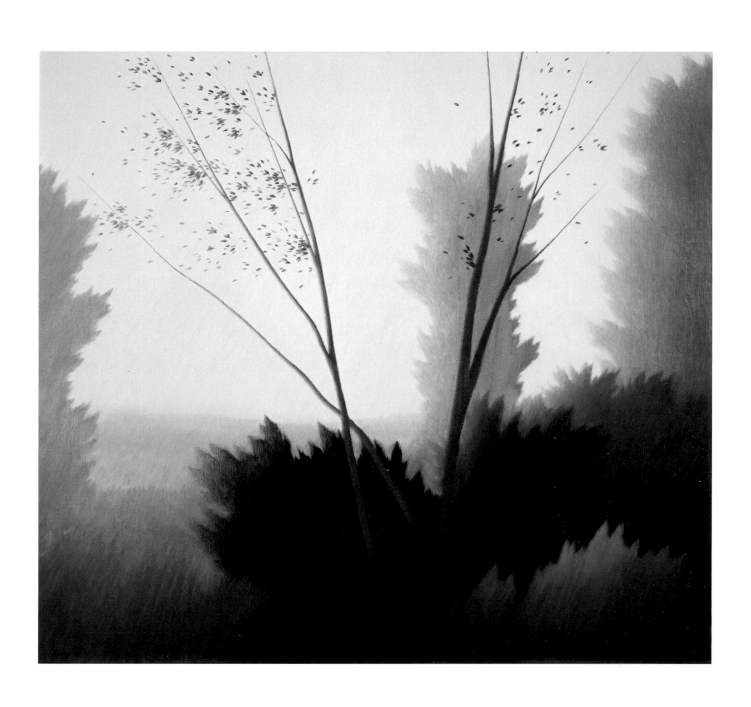

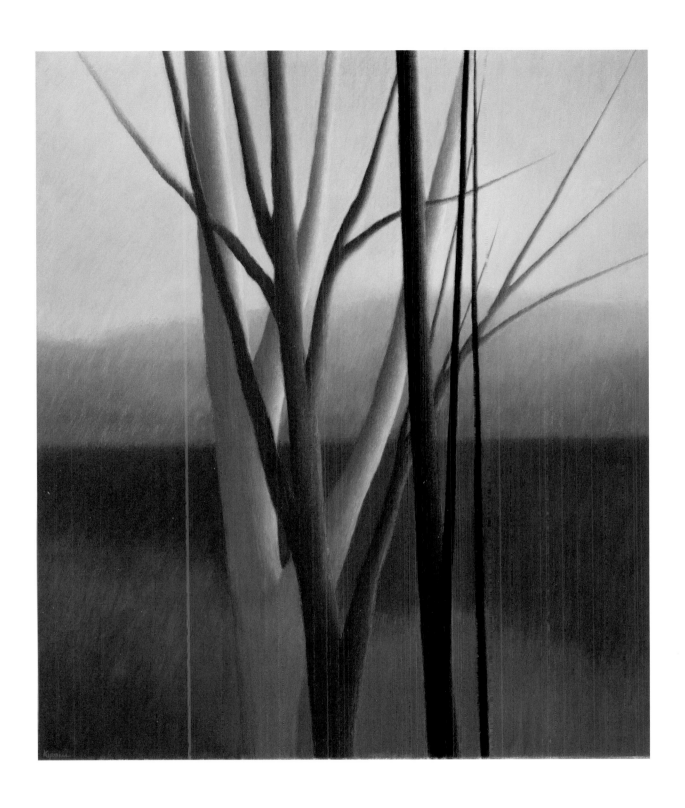

PLATE 37
Before Spring, 1998
oil on canvas, 32 × 28

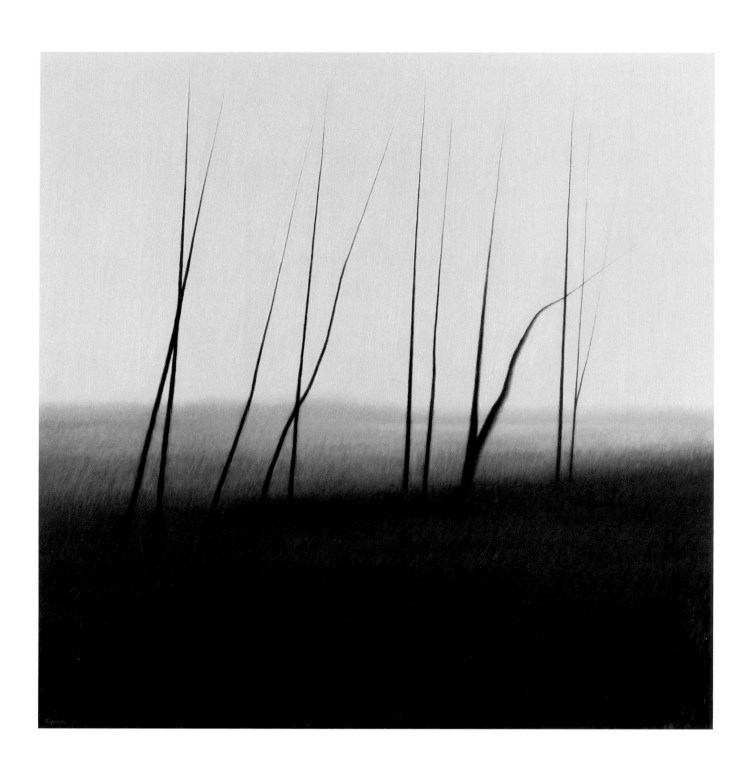

PLATE 38
Winter, 1998
oil on panel, 24 × 24

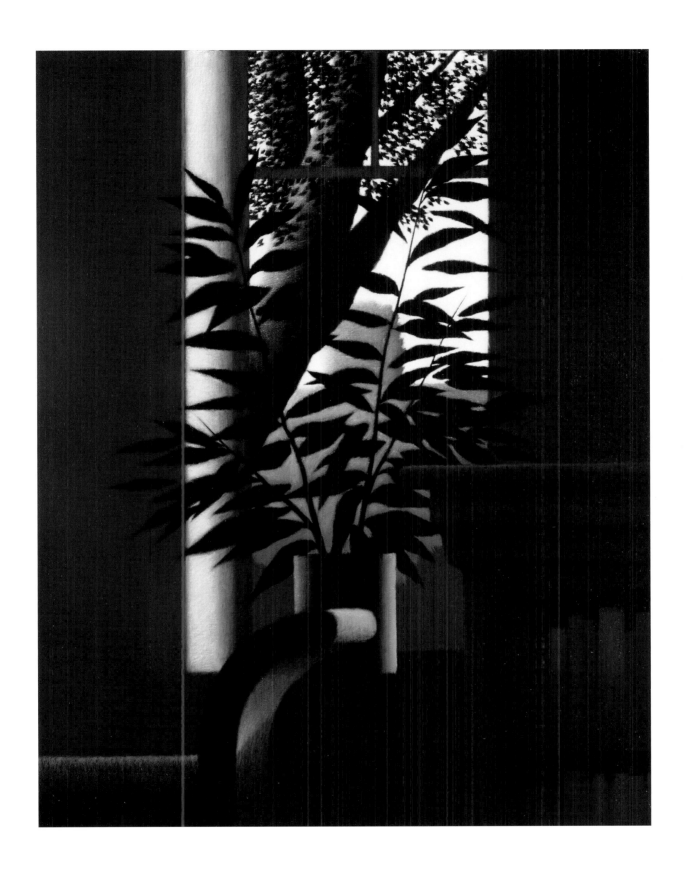

PLATE 39
Window with Bench and Tree, 1998
oil on canvas, 28 × 22

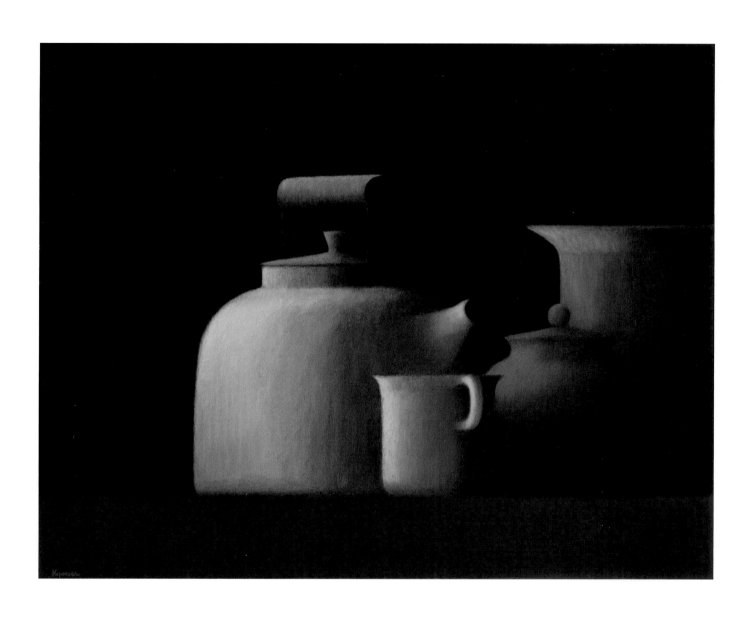

PLATE 40
Still Life with White Kettle, 1998
oil on panel, 20 × 25

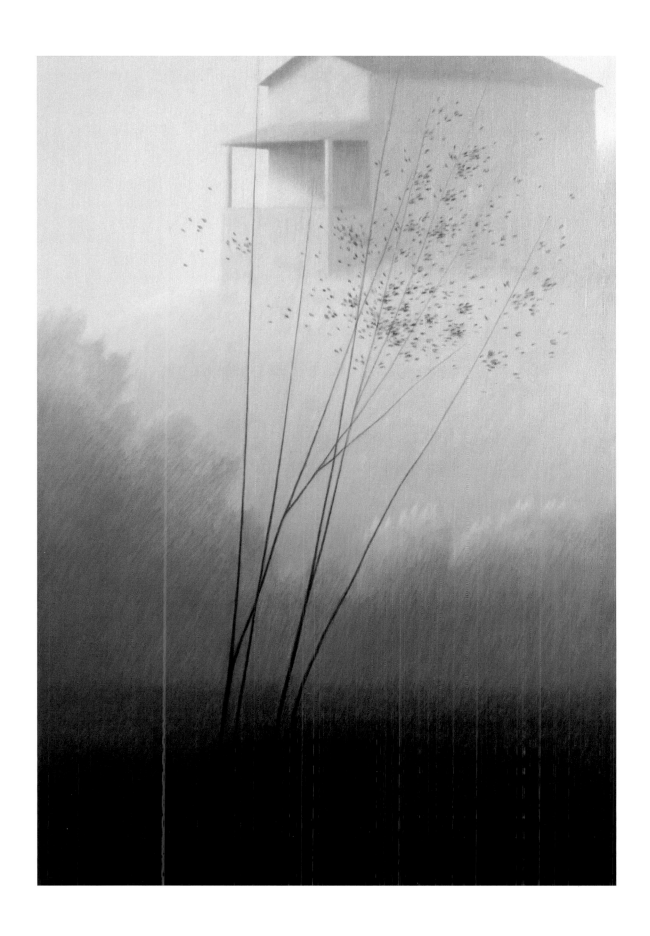

PLATE 41

Aloft, 1999

oil on canvas, 32 × 22

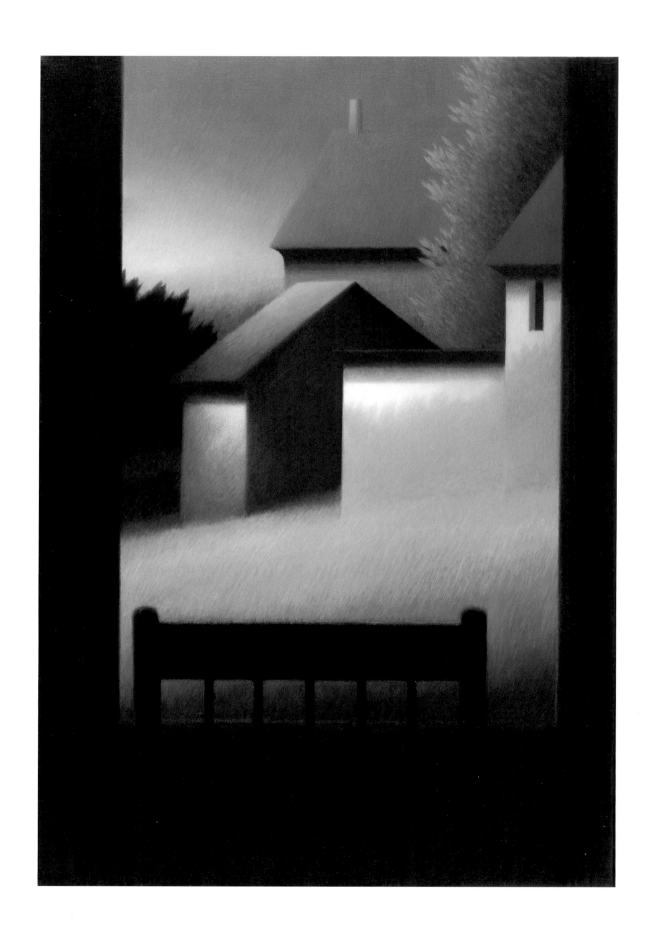

PLATE 42
Window at Dusk, 1999
oil on canvas, 36 × 24¾

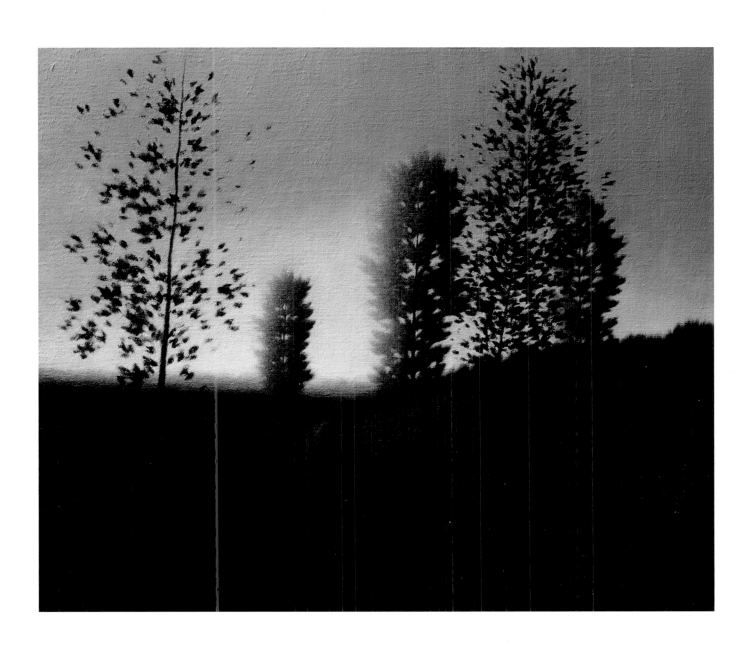

PLATE 43
Mist, 1999
oil on canvas, 20 × 24

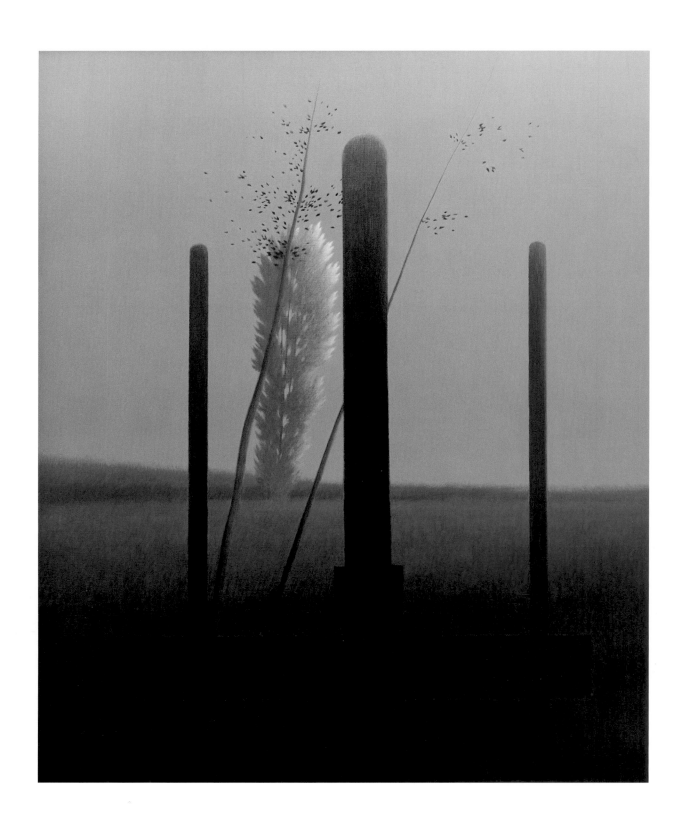

PLATE 44
The Artist's Studio, 1999
oil on canvas, 48 × 40

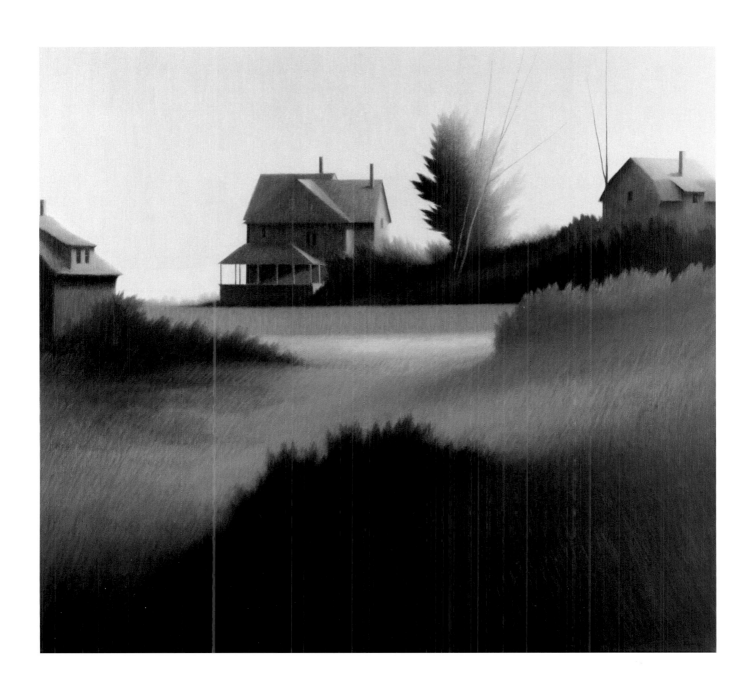

PLATE 45
Little Compton, 1999
oil on canvas, 36 × 40

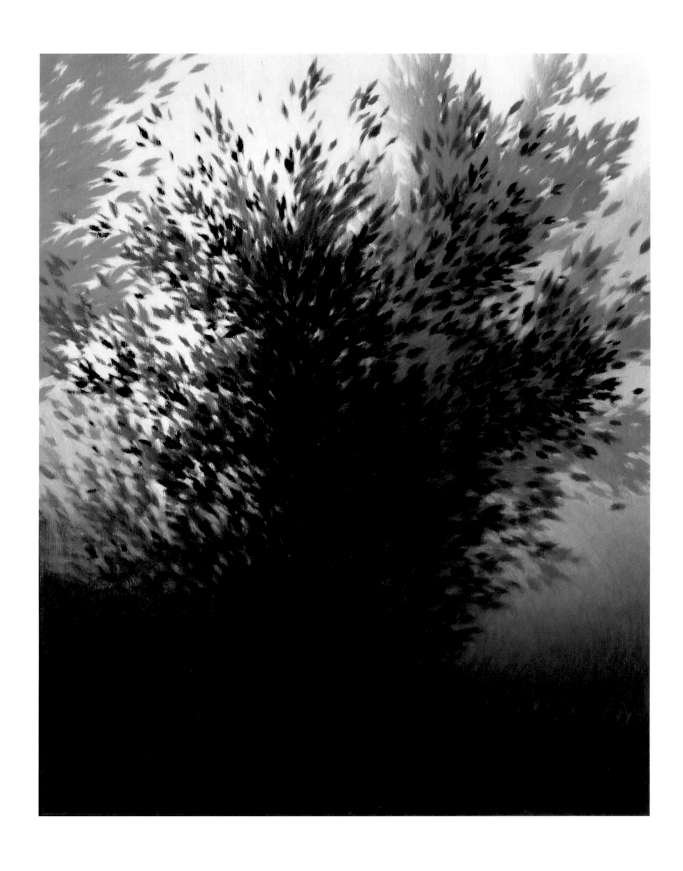

PLATE 46
Splash, 1999
oil on panel, 20 × 16

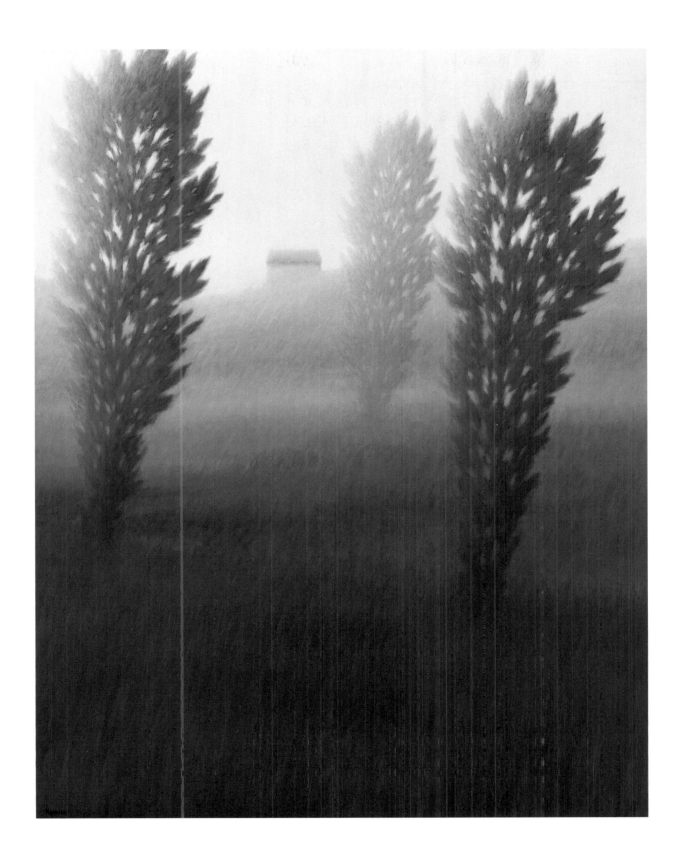

PLATE 47
The Far House, 1999
oil on panel, 25 × 20

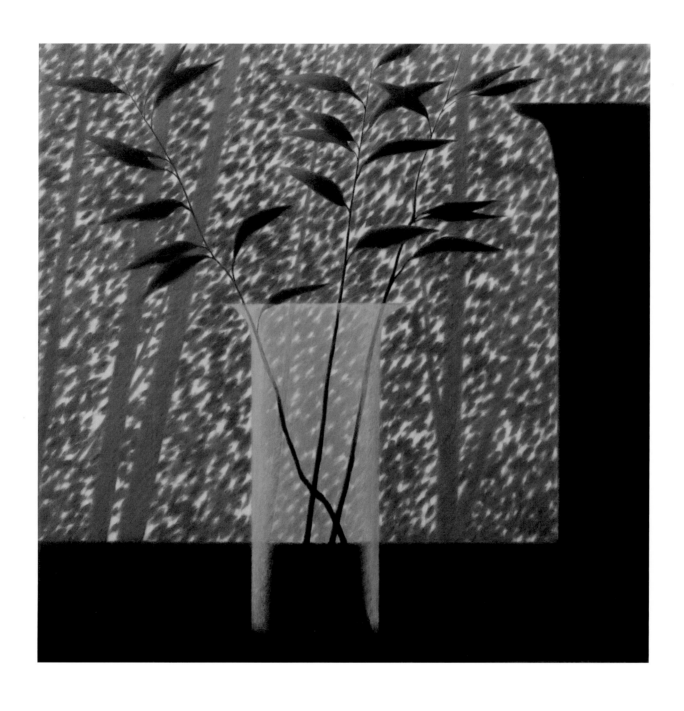

PLATE 48
Interior with Leaves, 1999
oil on canvas, 24 × 24

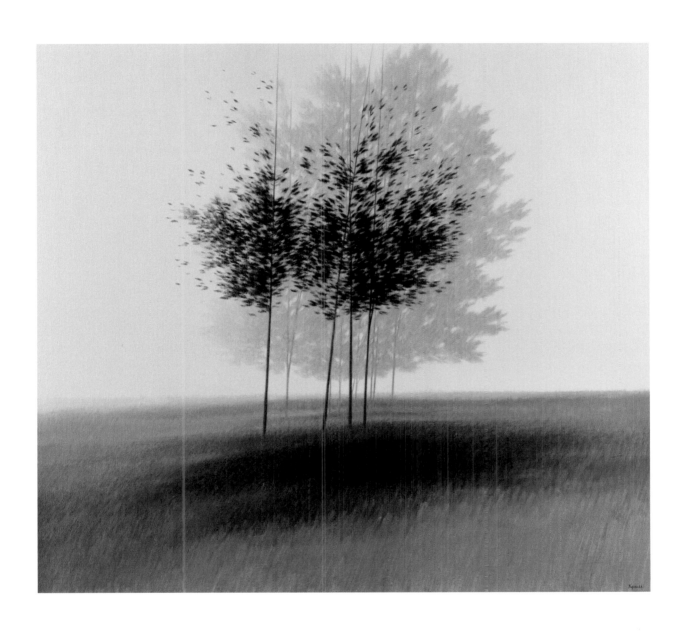

PLATE 49
Silver Morning, 2000
oil on canvas, 36 × 40

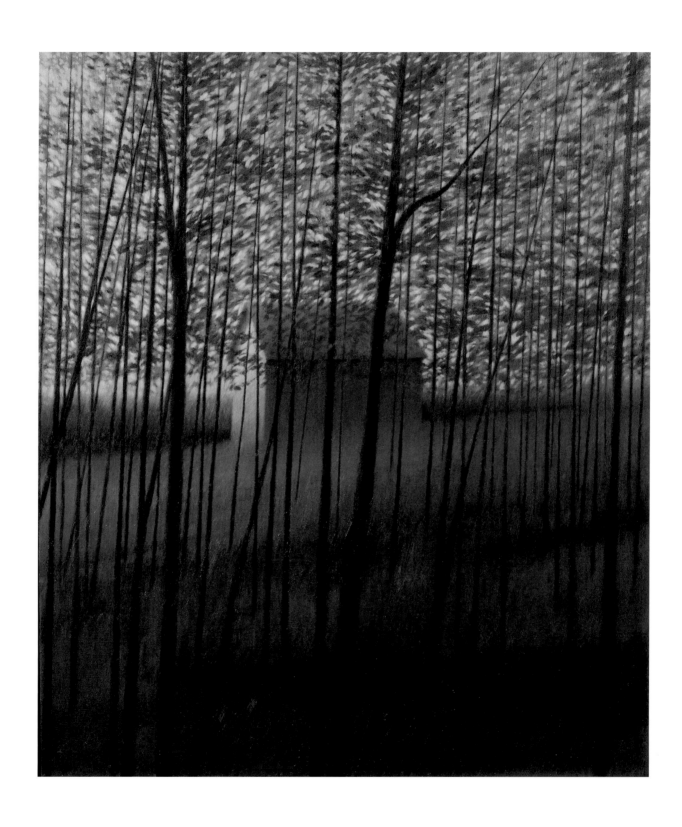

PLATE 50

Toward Long Ridge, 2000

oil on panel, 24 × 20

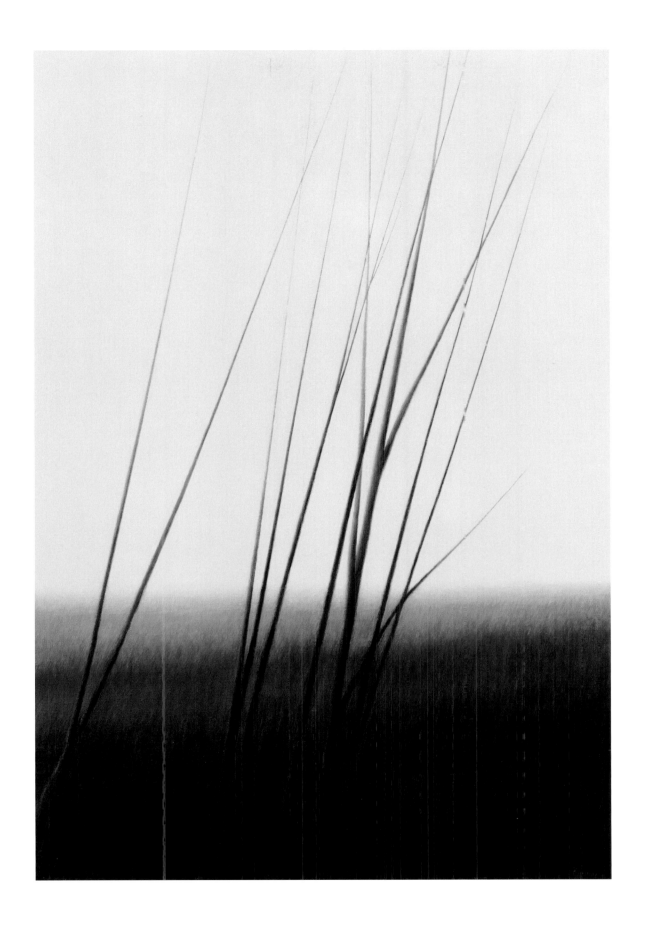

PLATE 51

Approaching, 2000

oil on canvas, 32 × 22

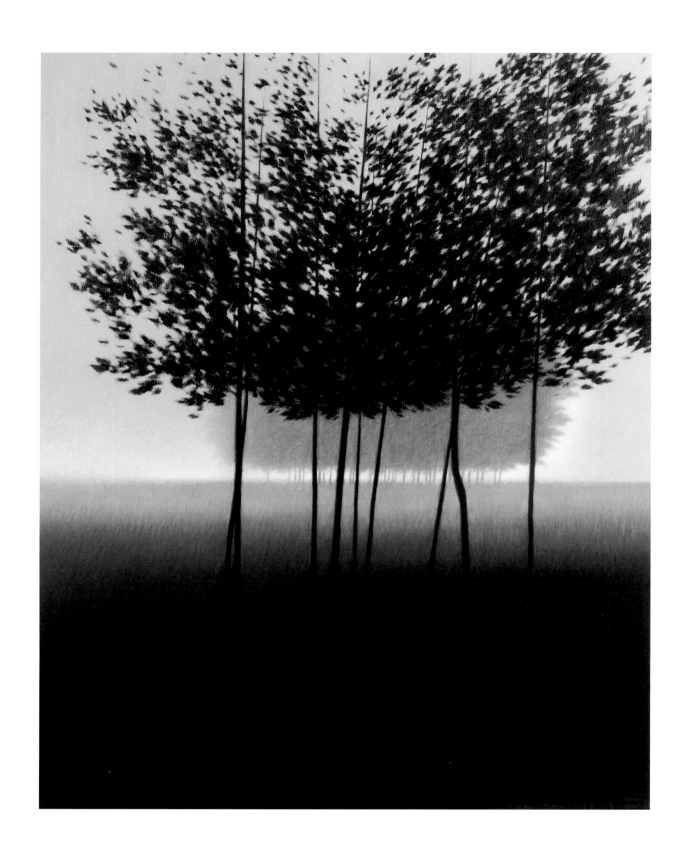

PLATE 52
Summer Evening, 2000
oil on canvas, 40 × 32

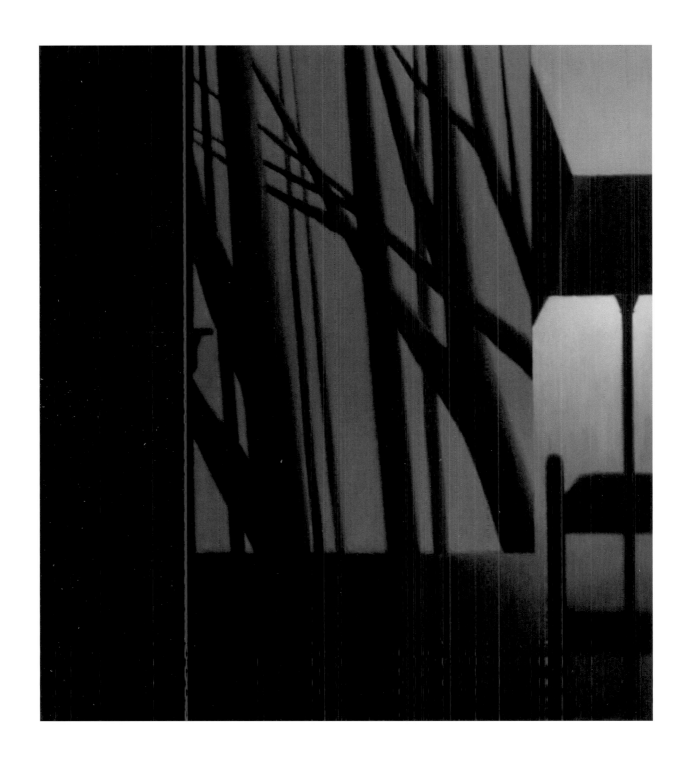

PLATE 53

Interior with Chair and Standing Lamp, 2000

oil on canvas, 40 × 36

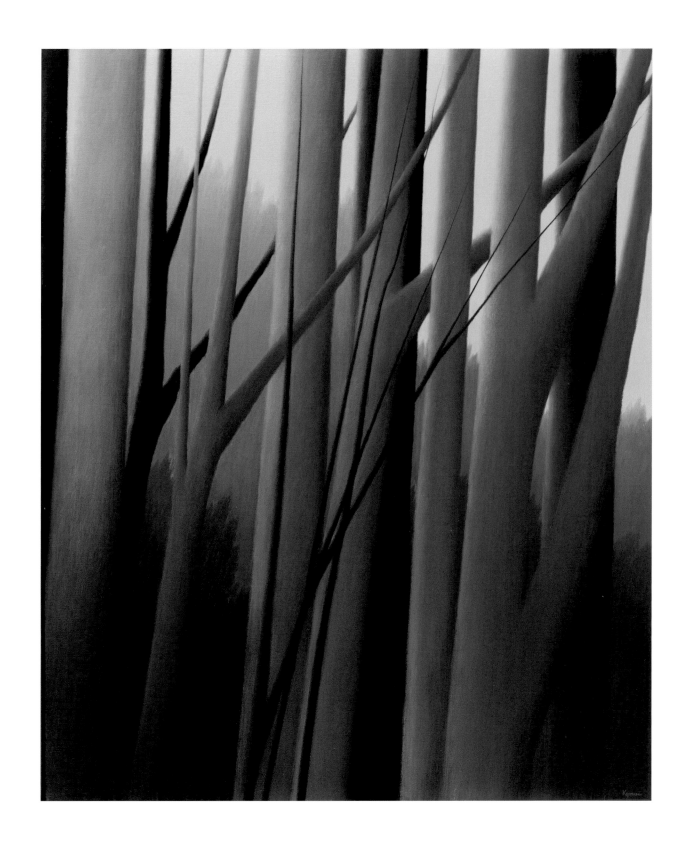

PLATE 54

Looking Through IV, 2000

oil on canvas, 40 × 32¼

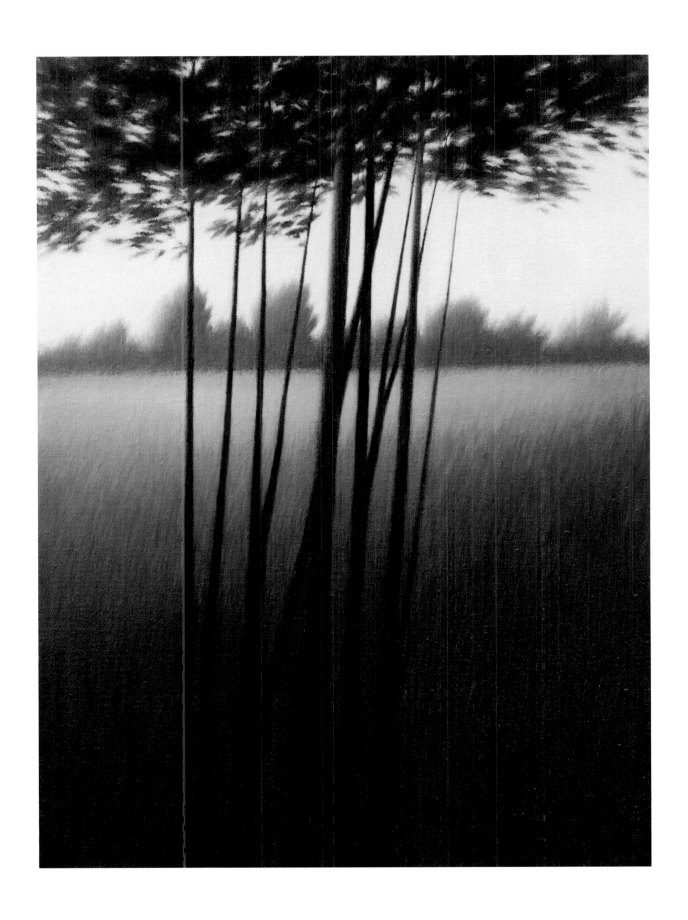

PLATE 55
A Small Field, 2002
oil on canvas, 24 × 18

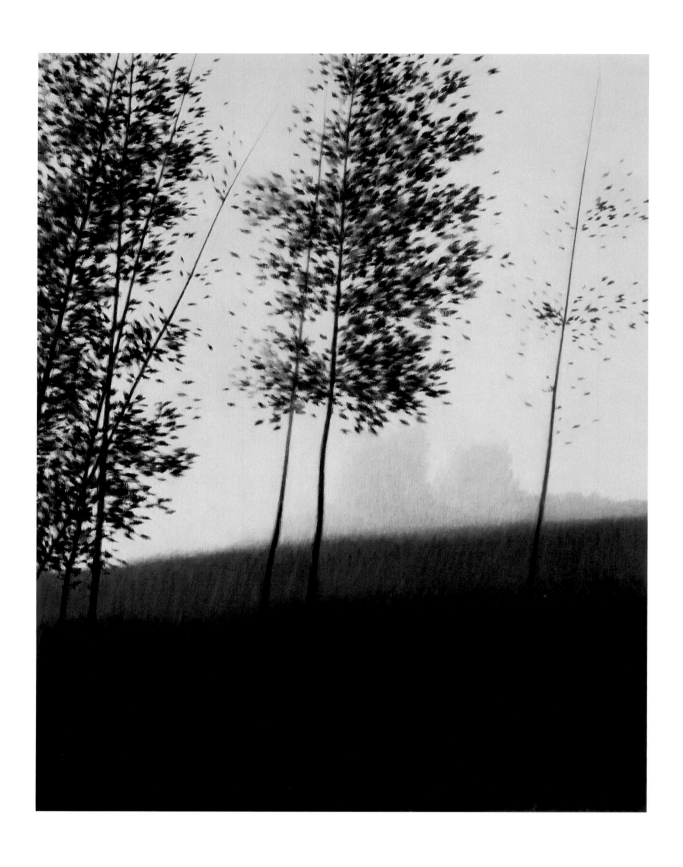

PLATE 56
Trees with Distant Mist, 2000
oil on canvas, 20 × 16

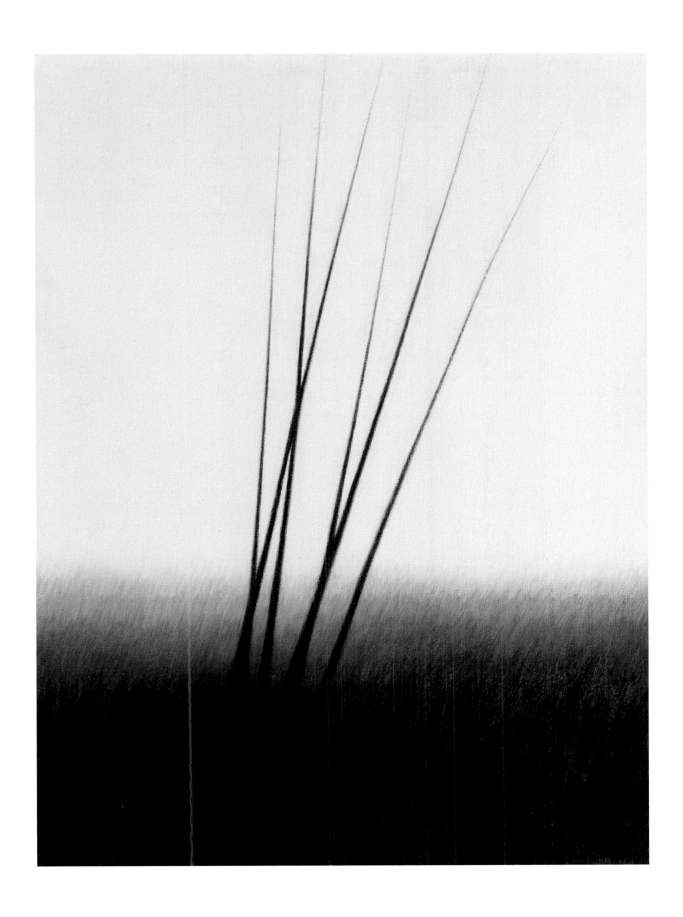

PLATE 57
Together, Solitary, 2000
oil on canvas, 16 × 12

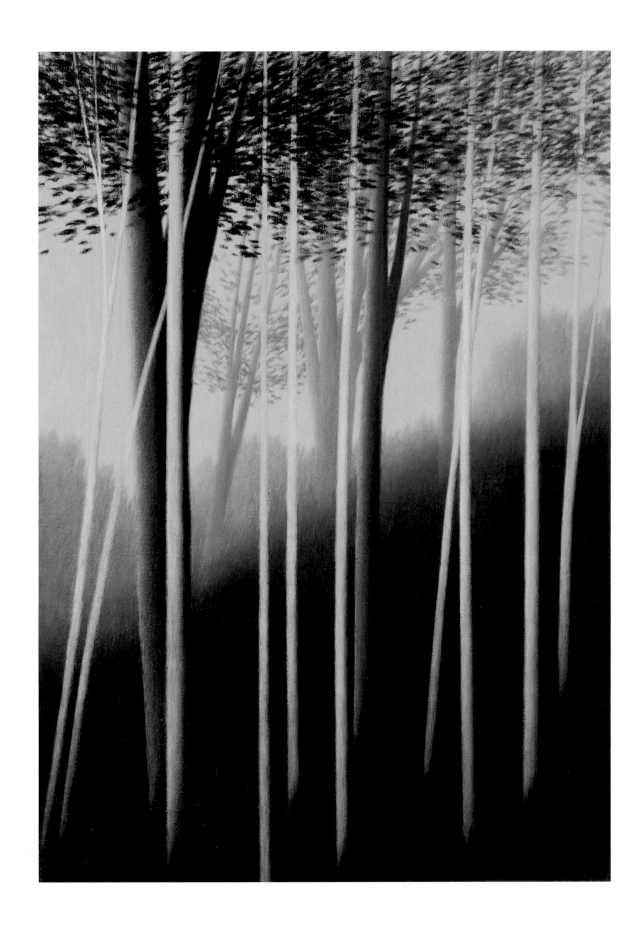

PLATE 58
Hillside Illusions II, 2001
oil on canvas, 32 × 22

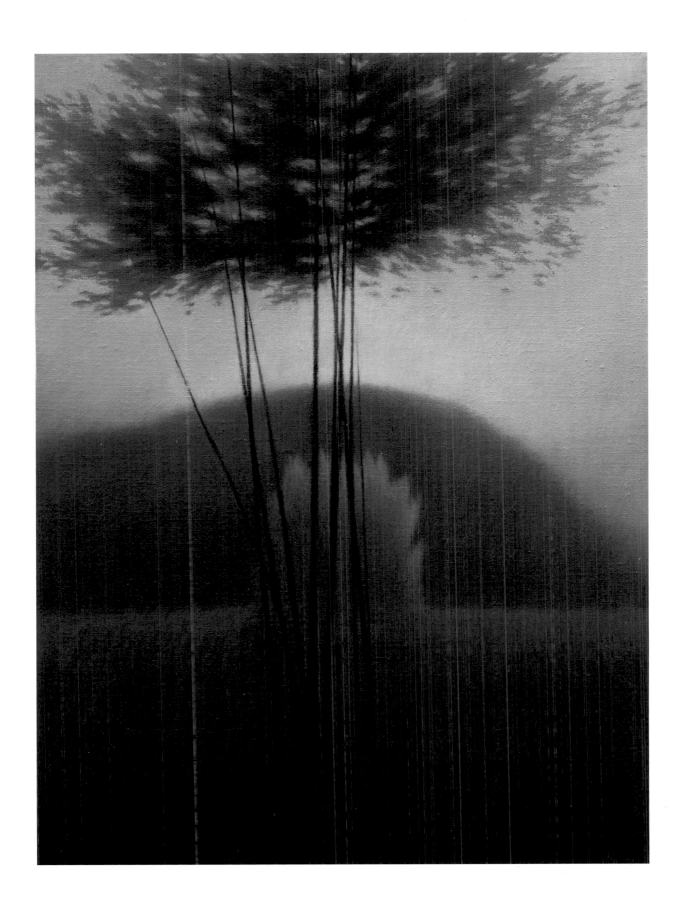

PLATE 59

Evening, 2001

oil on canvas, 24 × 18

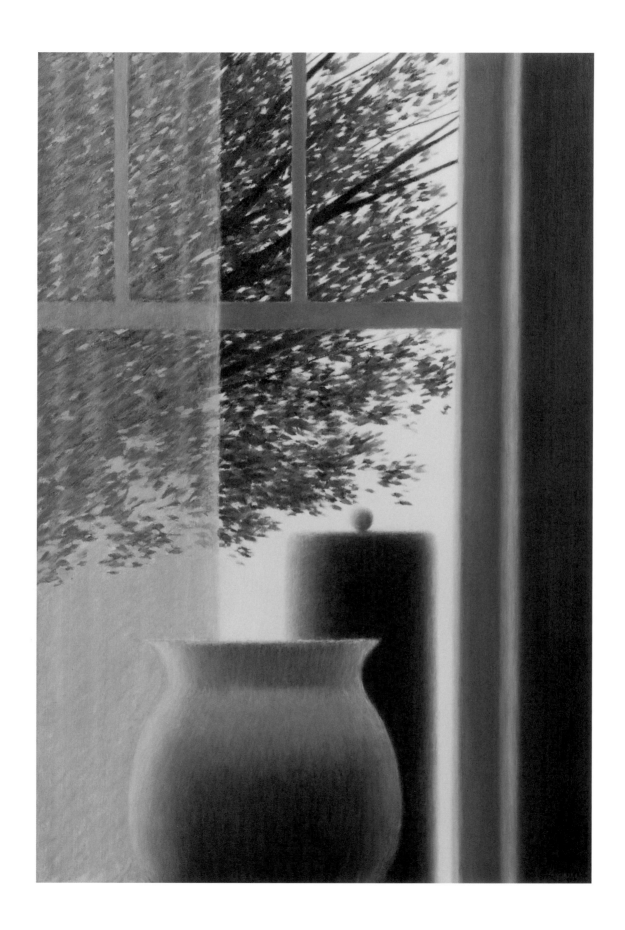

PLATE 60
Still Life with Curtains and Tree, 2001
oil on panel, 24 × 16

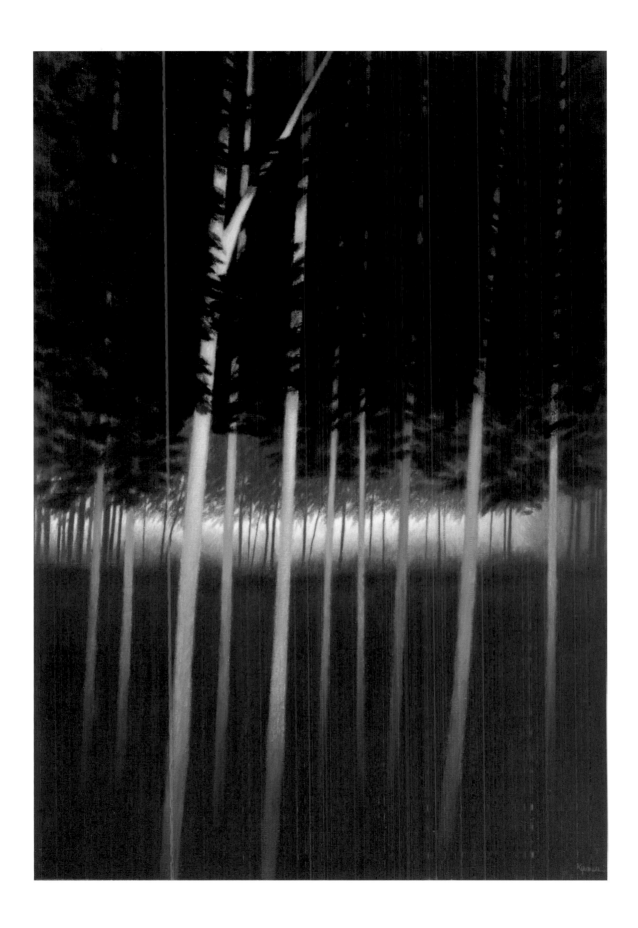

PLATE 61
Shelter, 2001
oil on canvas, 32 × 22

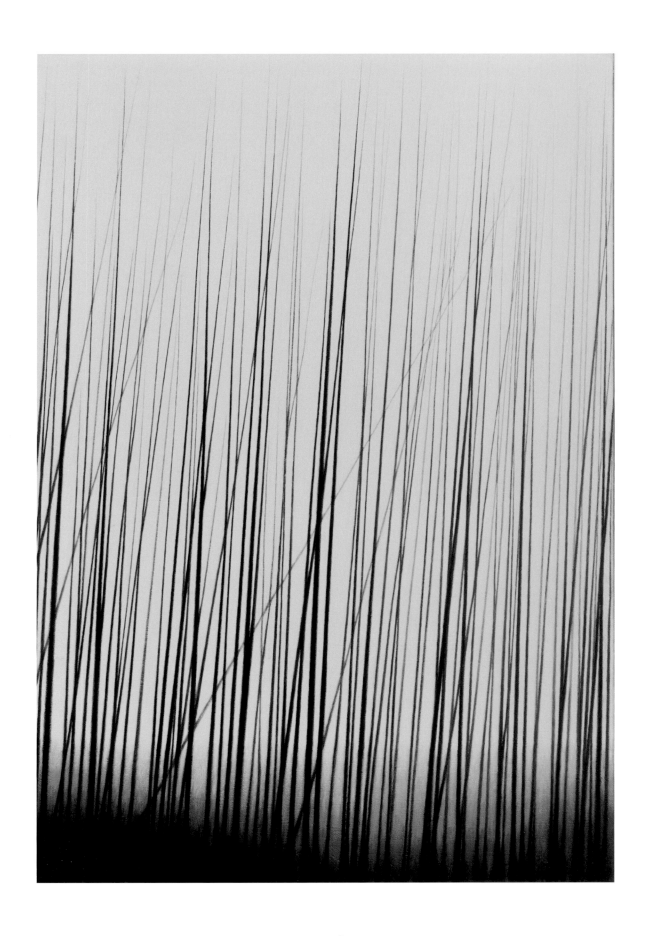

PLATE 62

Winter II, 2001
oil on canvas, 32 × 22

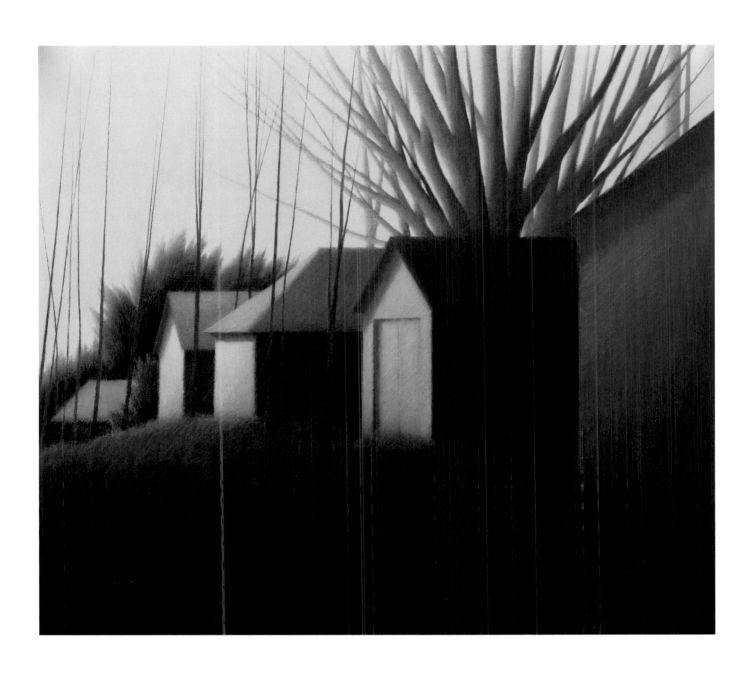

PLATE 63
Springfield, O. Sheds, 2001
oil on canvas, 28 × 32

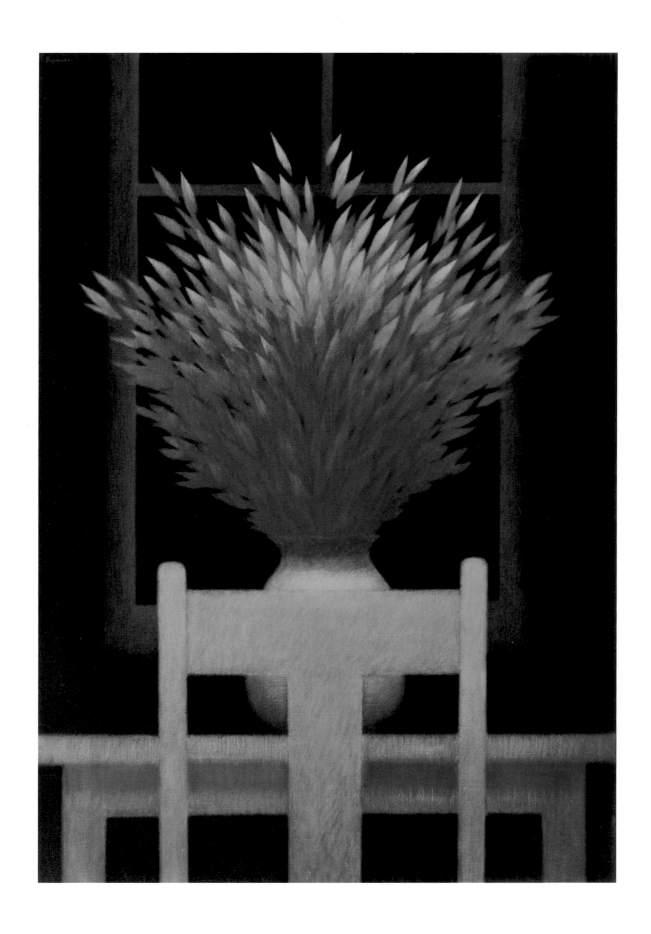

PLATE 64

Still Life with Dark Window, 2002

oil on canvas, 36 × 25

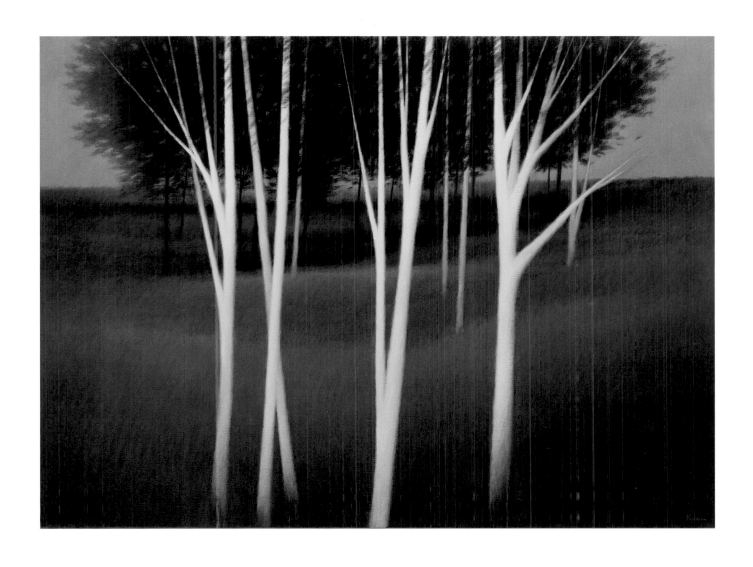

PLATE 65
Evening Figures, 2002
oil on canvas, 29¼ × 40

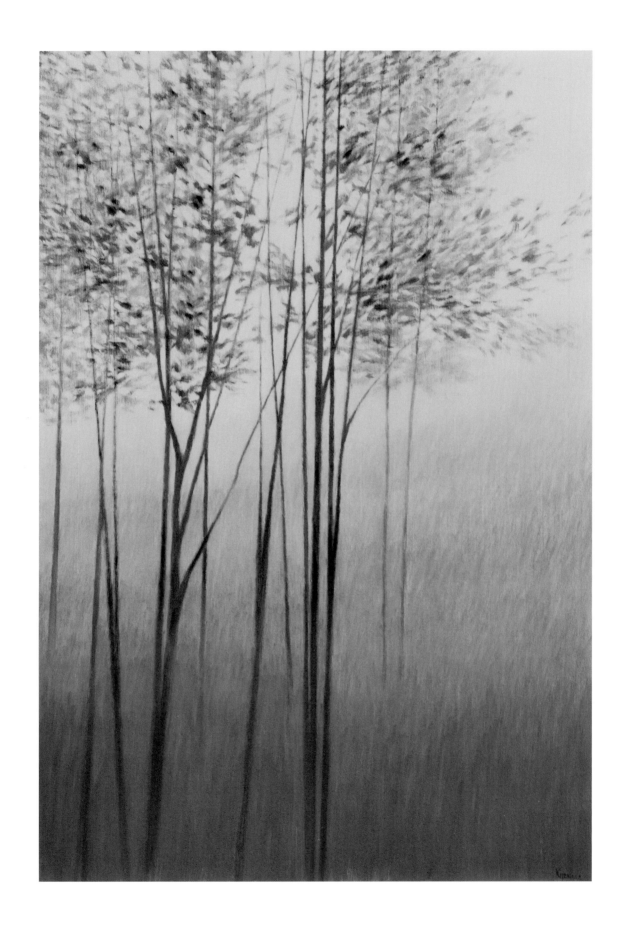

PLATE 66

Fields in Mist, 2002

oil on panel, 24 × 16

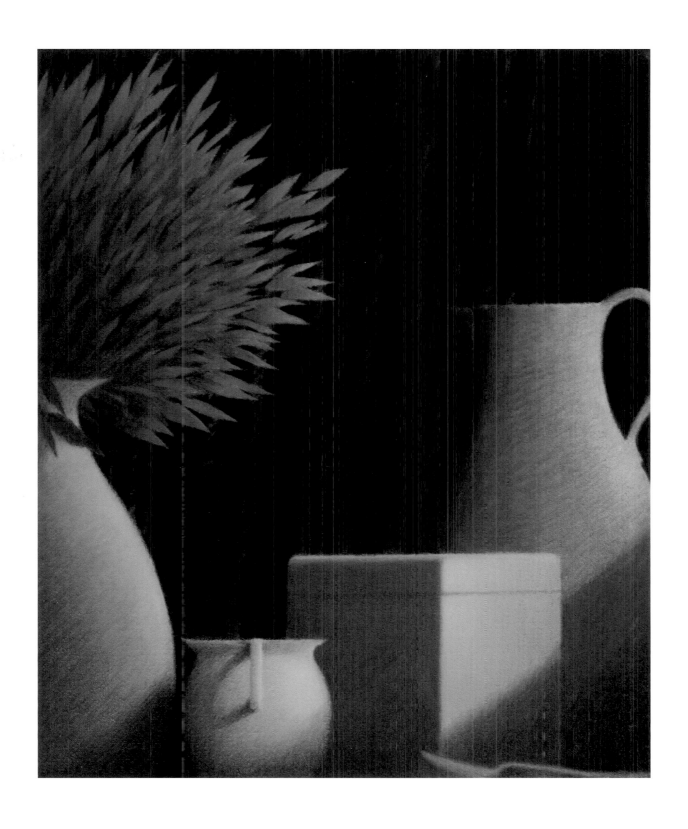

PLATE 67
Window with Spoon, 2002
oil on canvas, 24 × 20

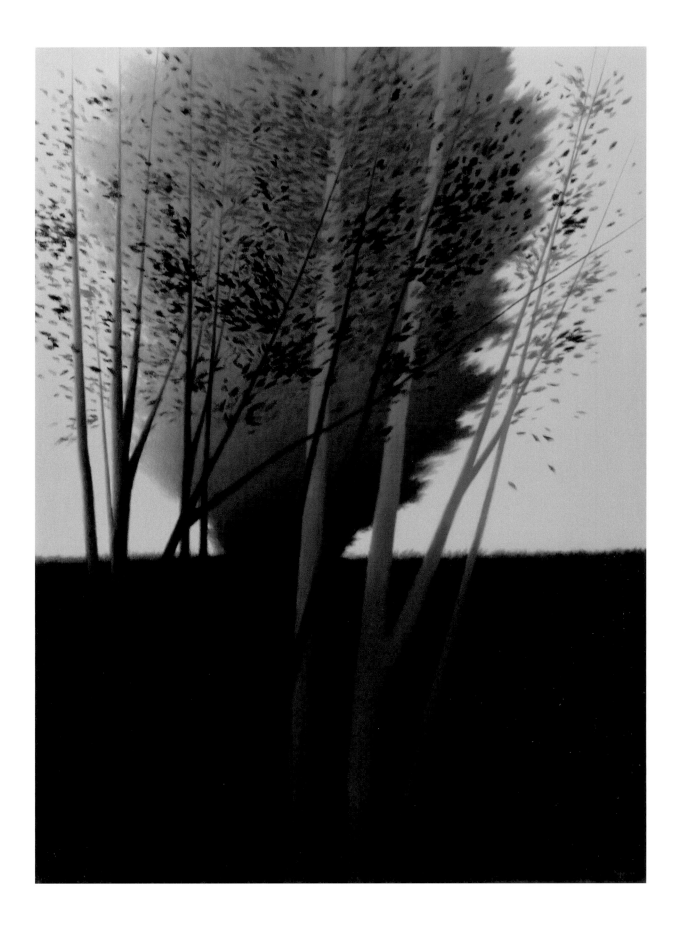

PLATE 68
Trees, 2002
oil on canvas, 40 × 29

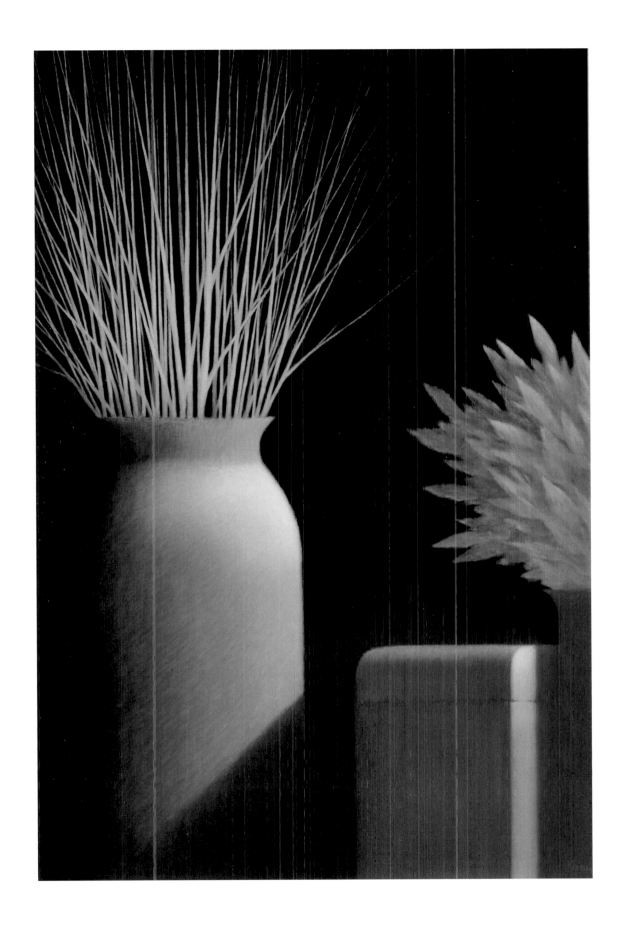

PLATE 69
Still Life with Two Vases, 2002
oil on panel, 24 × 16

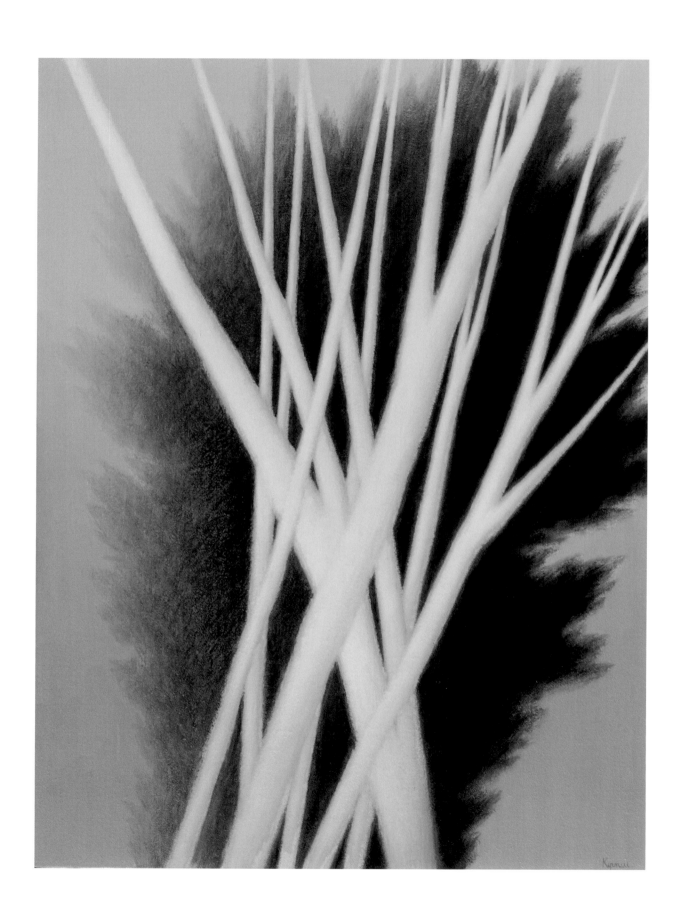

PLATE 70

Crossings, 2002

oil on canvas, 24 × 18

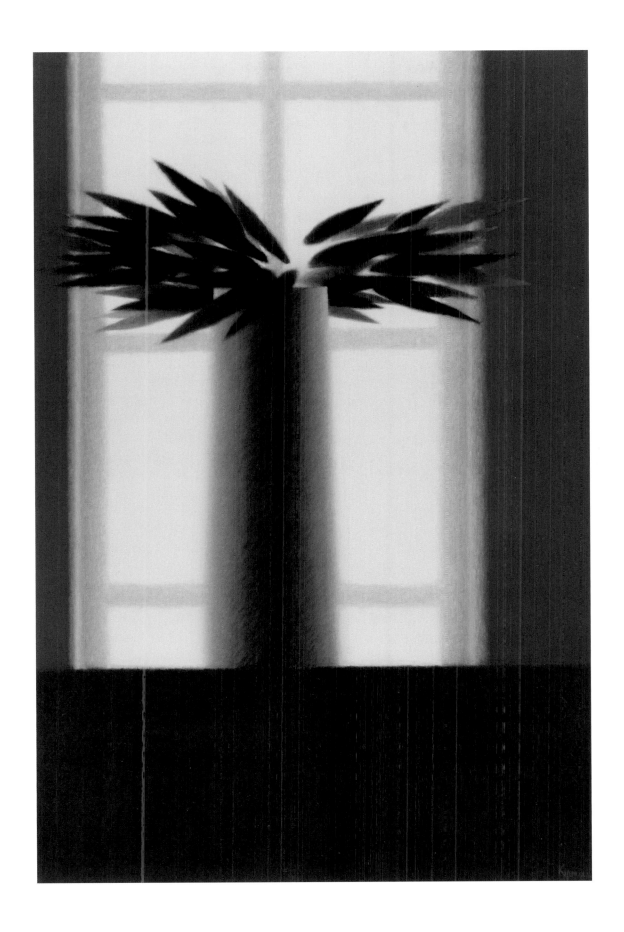

PLATE 71
Vase and Green Leaves, 2002
oil on panel, 24 × 16

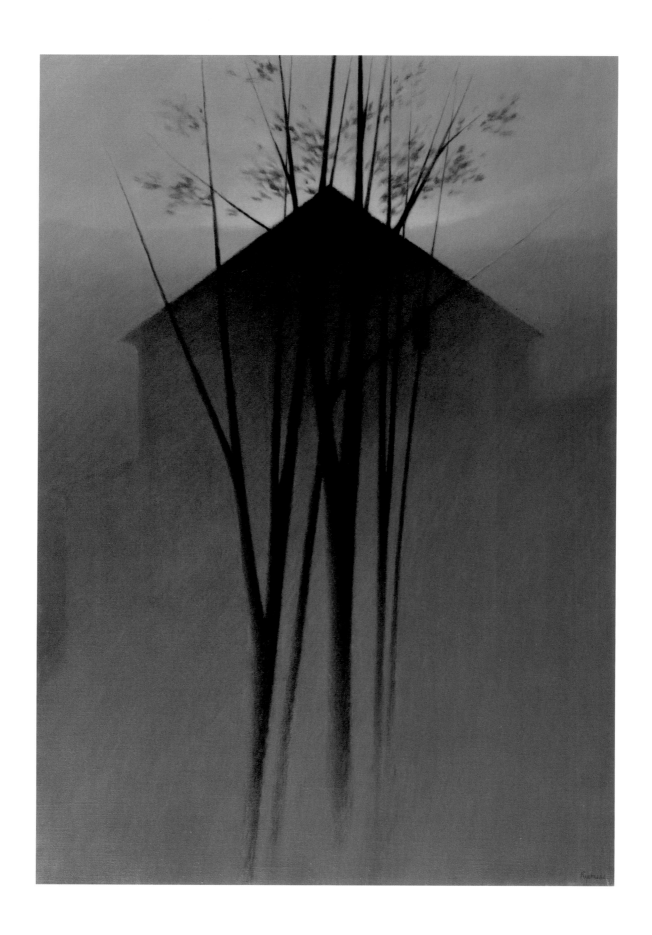

PLATE 72

Appearing I, 2002

oil on canvas, 36 × 25

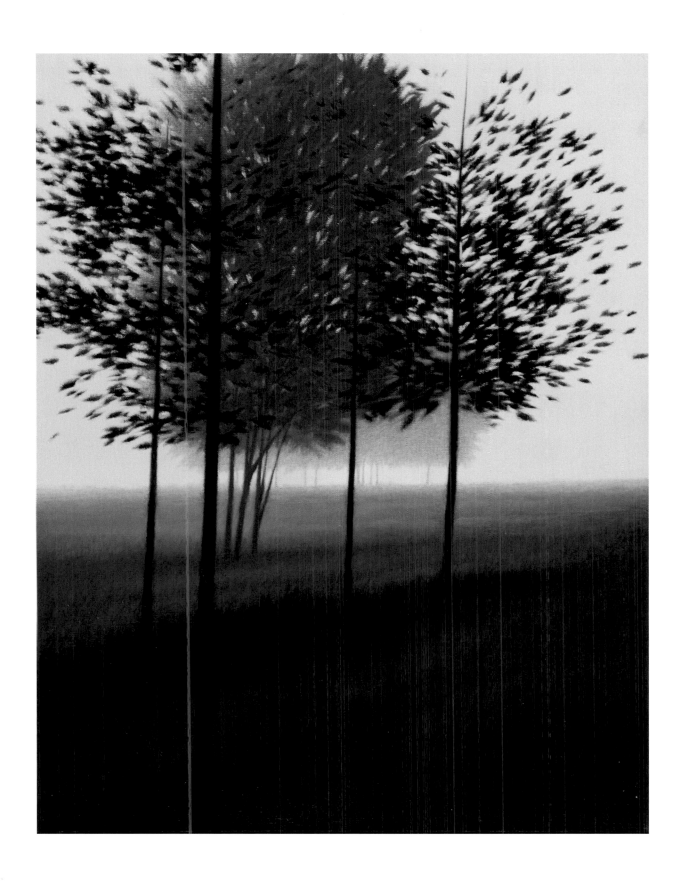

PLATE 73

Splash III, 2003

oil on canvas, 28 × 22

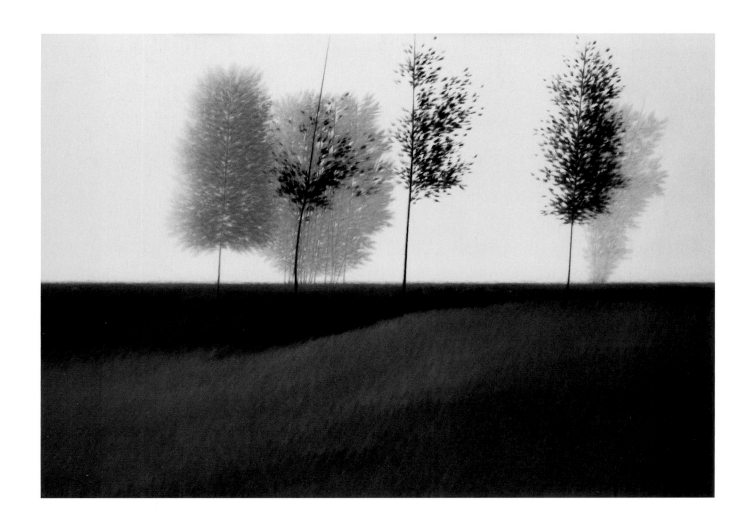

PLATE 74

Premonitions, 2003

oil on canvas, 25 × 36¼

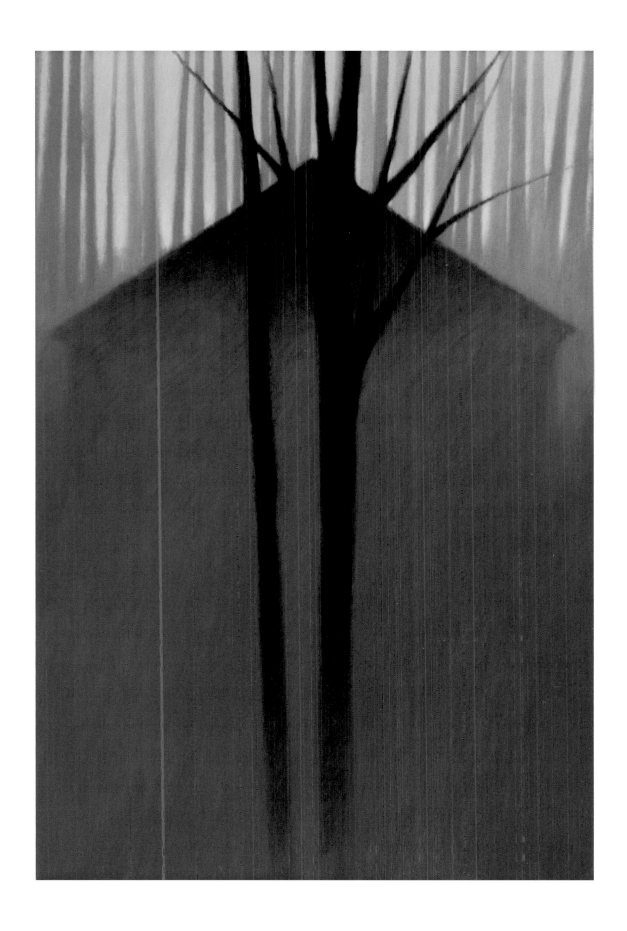

PLATE 75
Appearing II, 2004
oil on panel, 24 × 16

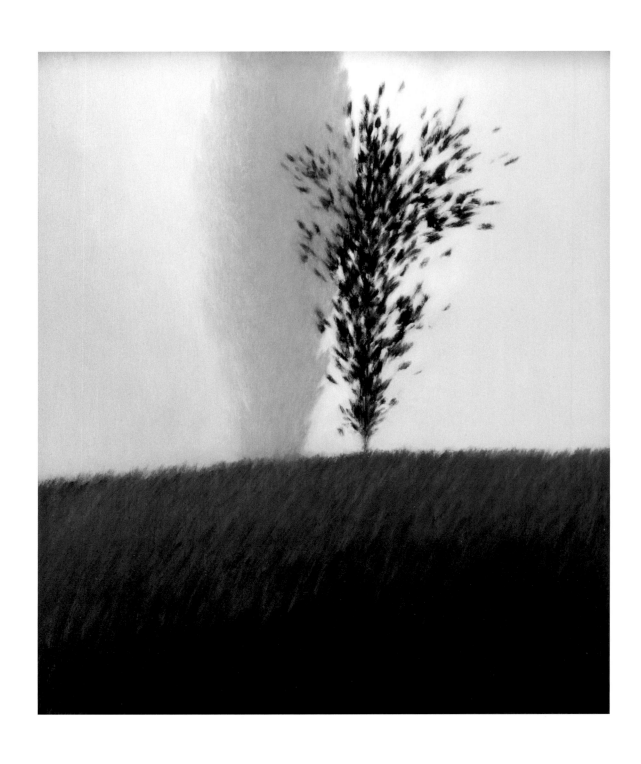

PLATE 76

On Point, 2004

oil on panel, 14 × 12

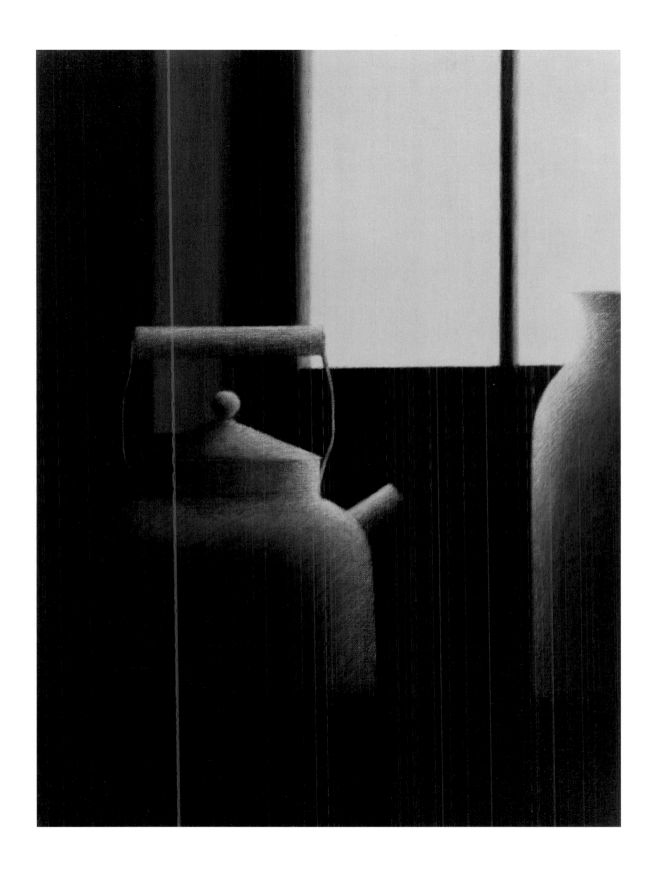

PLATE 77
Window with Kettle and Vase, 2004
oil on canvas, 24 × 18

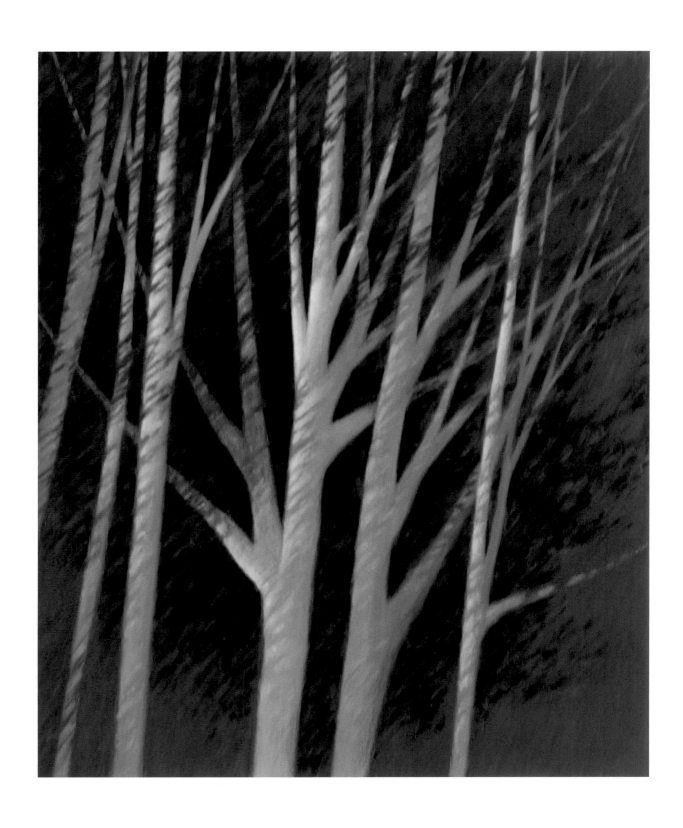

PLATE 78

Nocturne with Six Trees II, 2004

oil on panel, 24 × 20

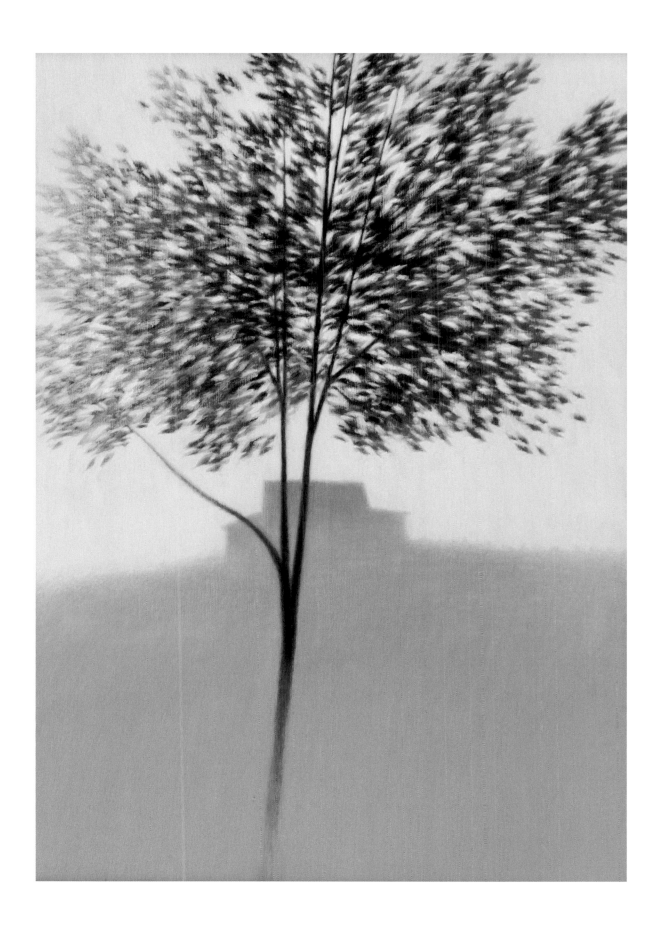

PLATE 79
Tribute, 2004
oil on panel, 20 × 14

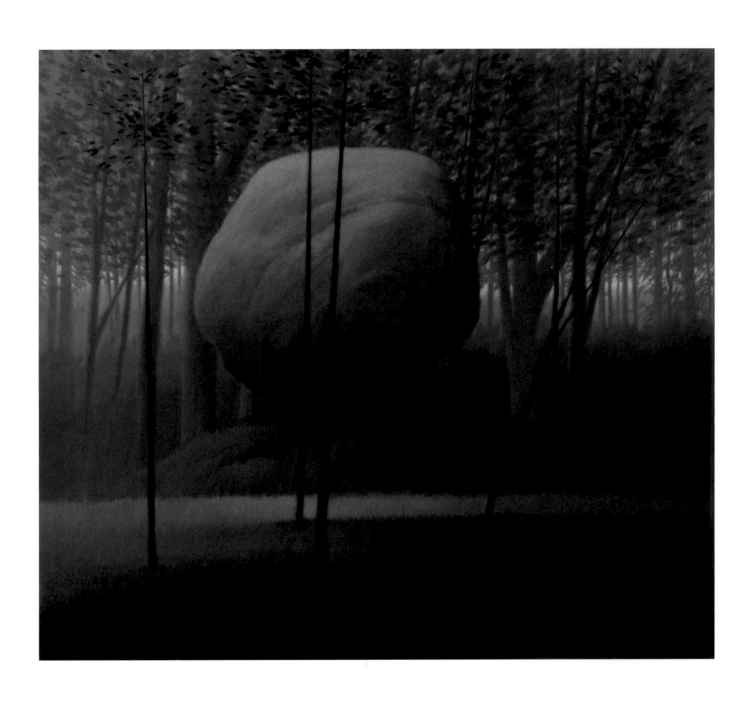

PLATE 80

The Balanced Rock, 2004

oil on canvas, 40 × 36

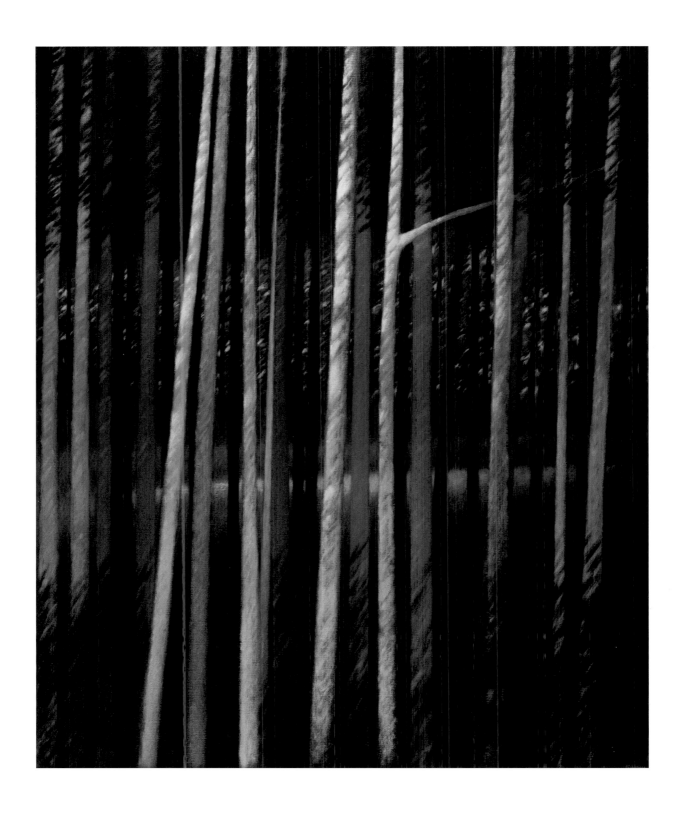

PLATE 81
Near the Clearing, 2004
oil on canvas, 47¾ × 39¾

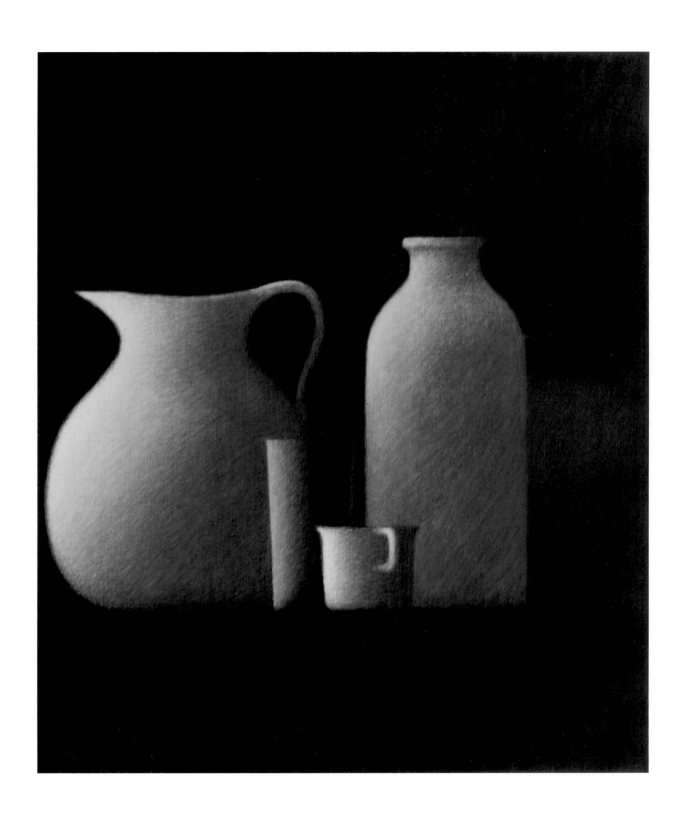

PLATE 82

Table-top Nocturne, 2004

oil on canvas, 24 × 20

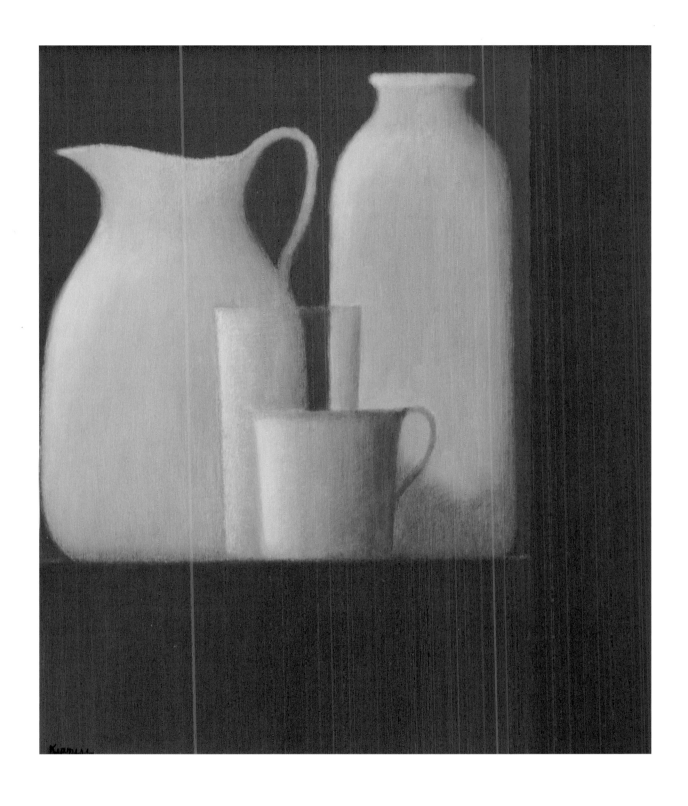

PLATE 83
Still Life with Glass and Cup, 2004
oil on panel, 14 × 12

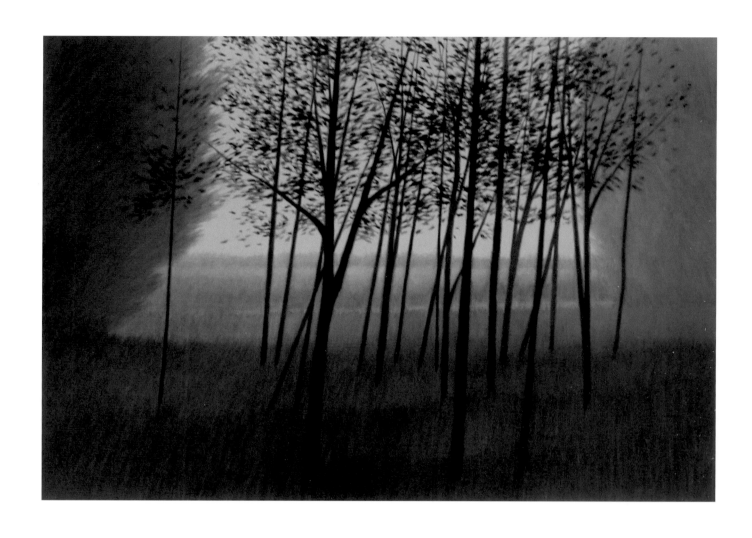

PLATE 84

Intervention, 2004

oil on canvas, 25 × 36

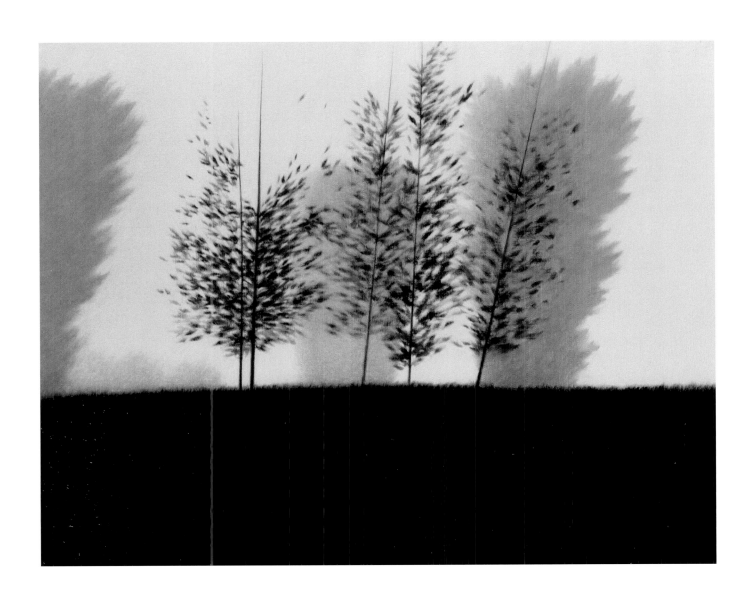

PLATE 85
The Stage, 2004
oil on canvas, 22 × 28

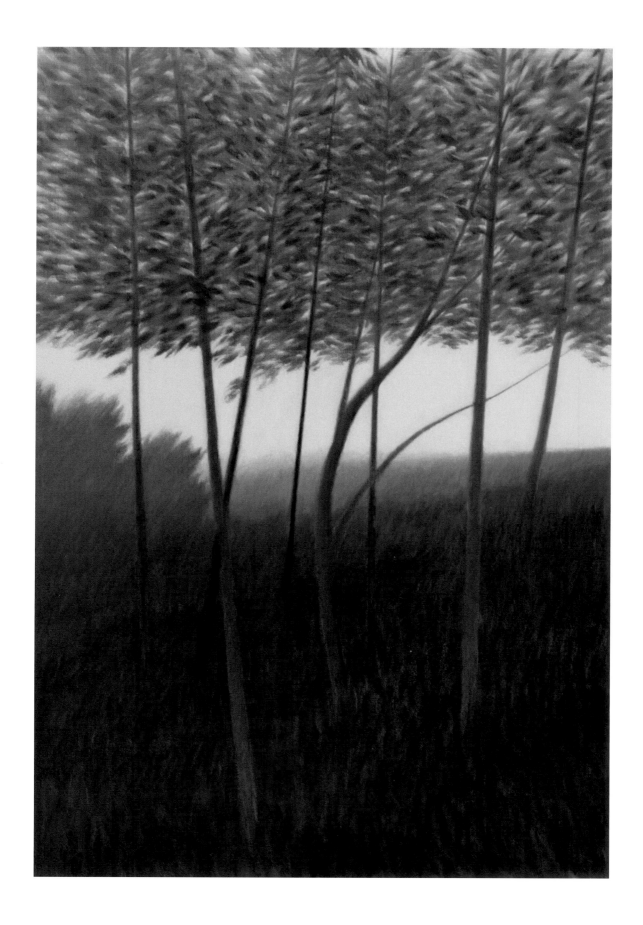

PLATE 86
Green, Green, 2004
oil on canvas, 32 × 22

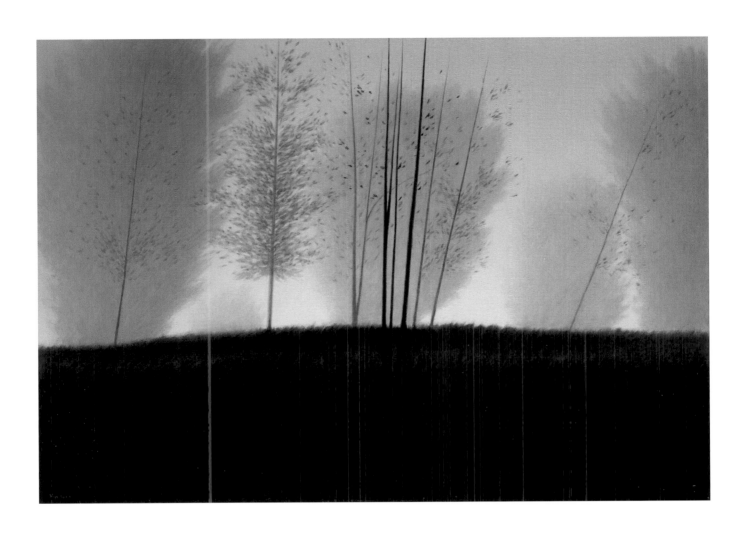

PLATE 87
Silver Morning II, 2004
oil on canvas, 22 × 28

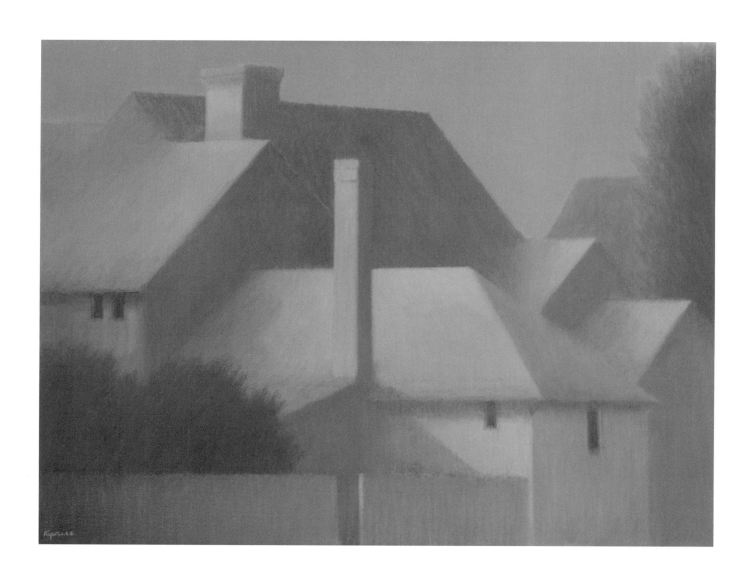

PLATE 88

At Shire, 2004

oil on canvas, 18 × 24

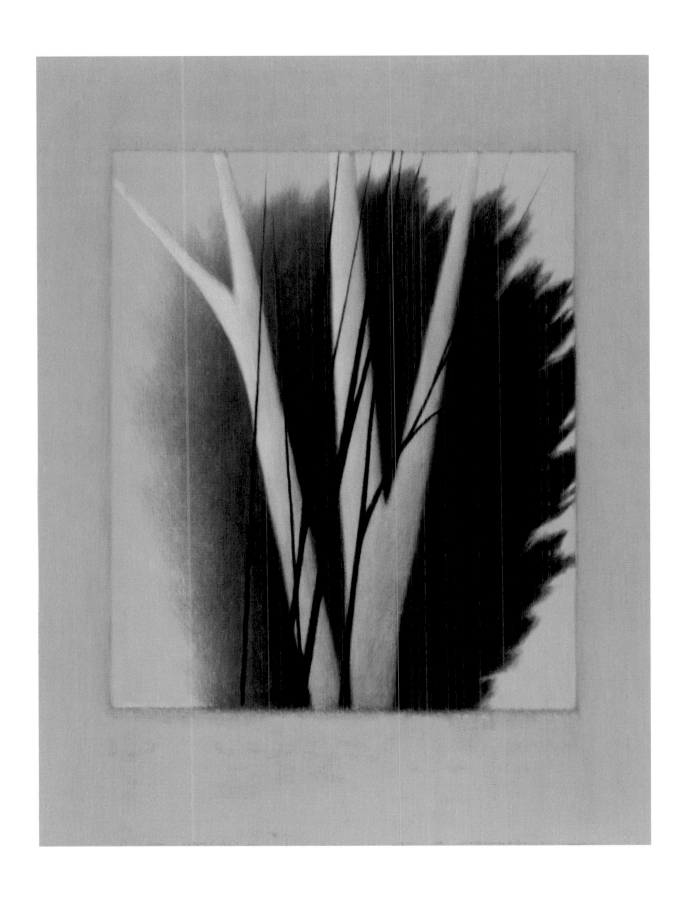

PLATE 89
Presentation: Trees, 2004
oil on canvas, 28 × 22

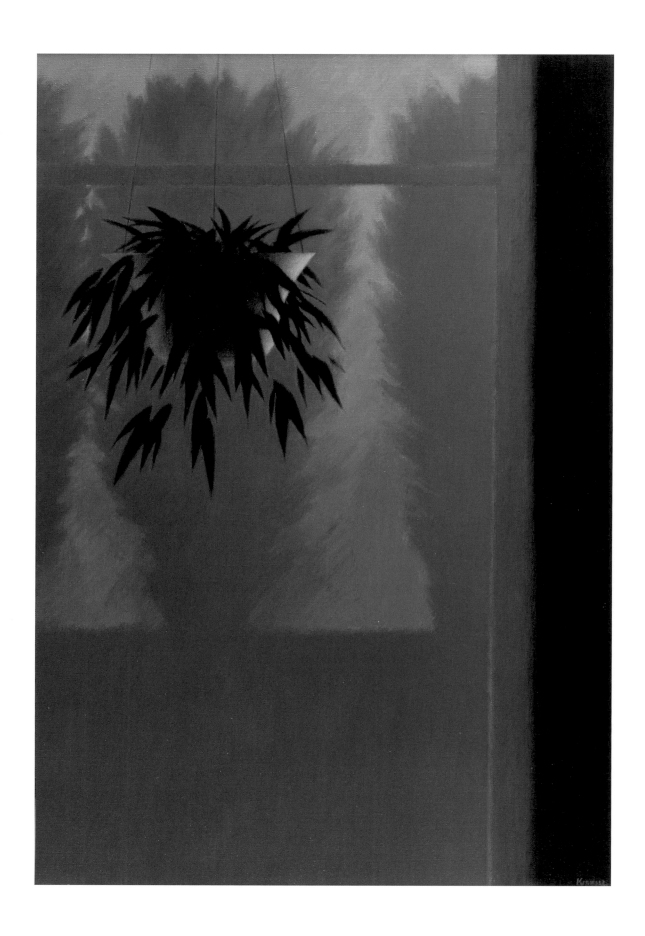

PLATE 90

Window with Hanging Plant, 2004

oil on canvas, 32 × 22

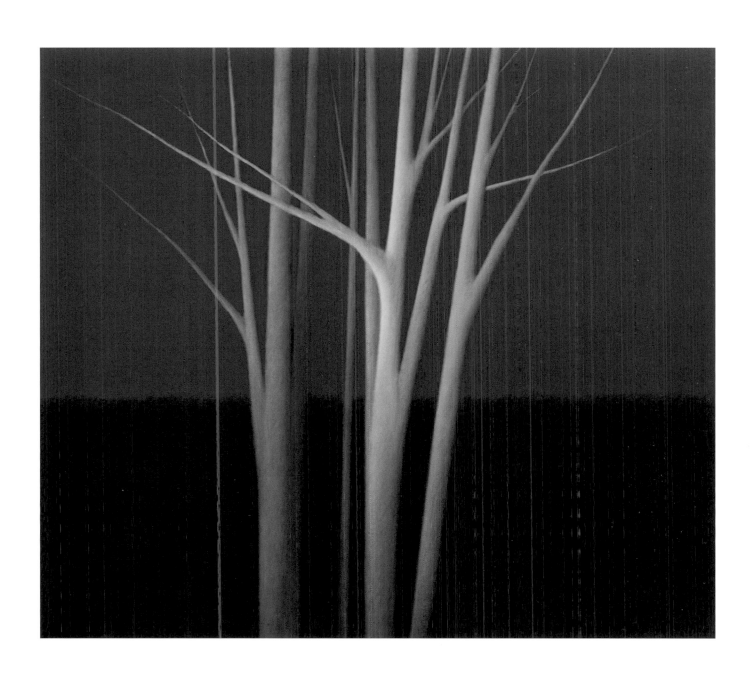

PLATE 91

Testament, 2005

oil on canvas, 28 × 32

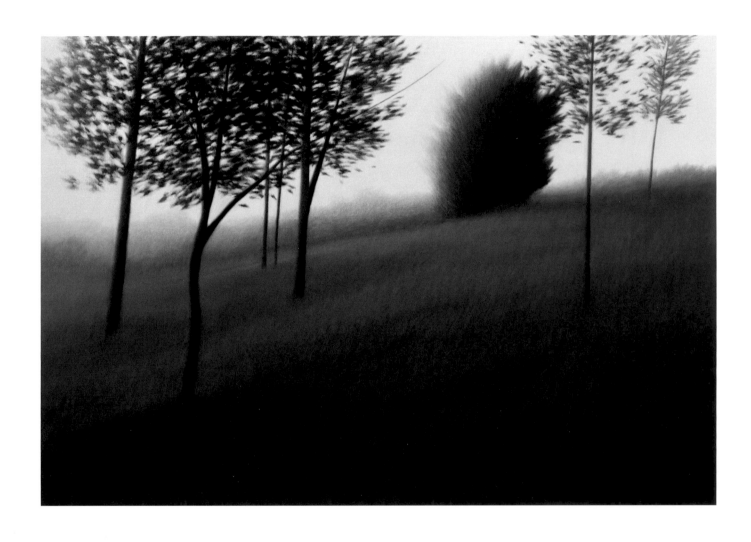

PLATE 92
Green Slope, 2005
oil on canvas, 25 × 36

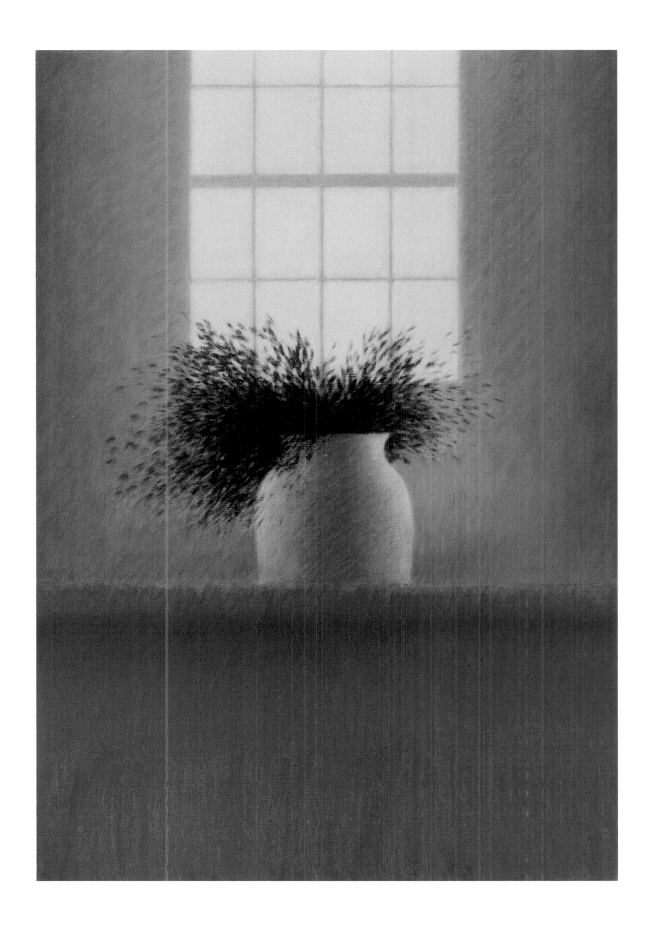

PLATE 93
Interior with Window and Pot, 2005
oil on canvas, 29 × 22

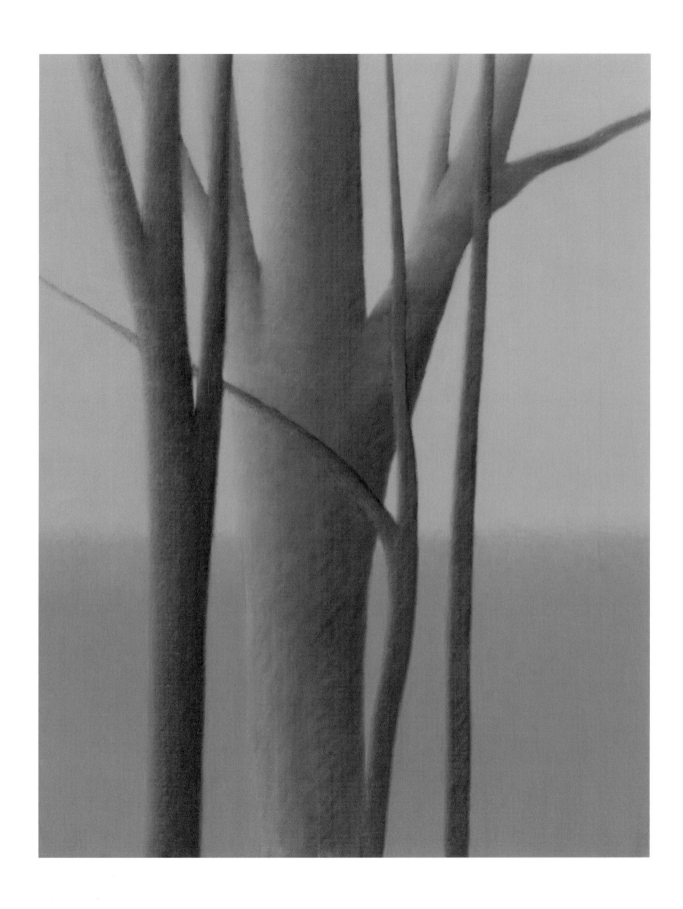

PLATE 94
Study in Gray and Green, 2005
oil on canvas, 24 × 18

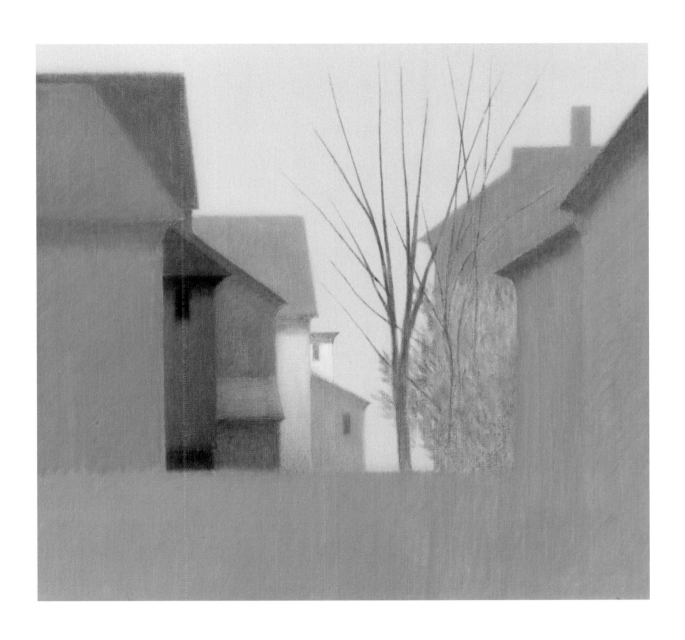

PLATE 95
Springfield, O. III, 2025
oil on canvas, 20¼ × 22

PLATE 96
Vase and Leaves I, 2005
oil on panel, 20 × 14

PLATE 97
Vase and Leaves II, 2005
oil on panel, 24 × 16

PLATE 98
Vase and Leaves III, 2005
oil on canvas, 23 × 18

PLATE 99
Vase and Leaves IV, 2005
oil on canvas, 20¼ × 22

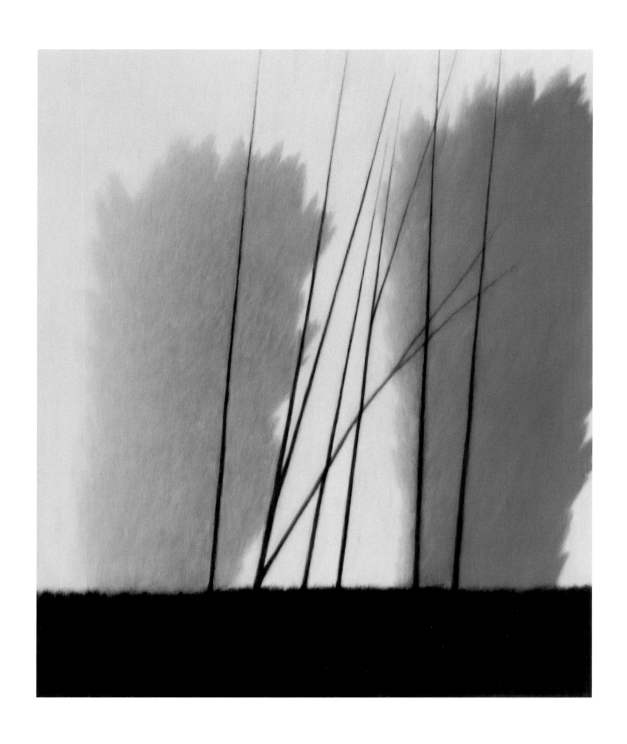

PLATE 100

Poised, 2005

oil on panel, 14 × 12

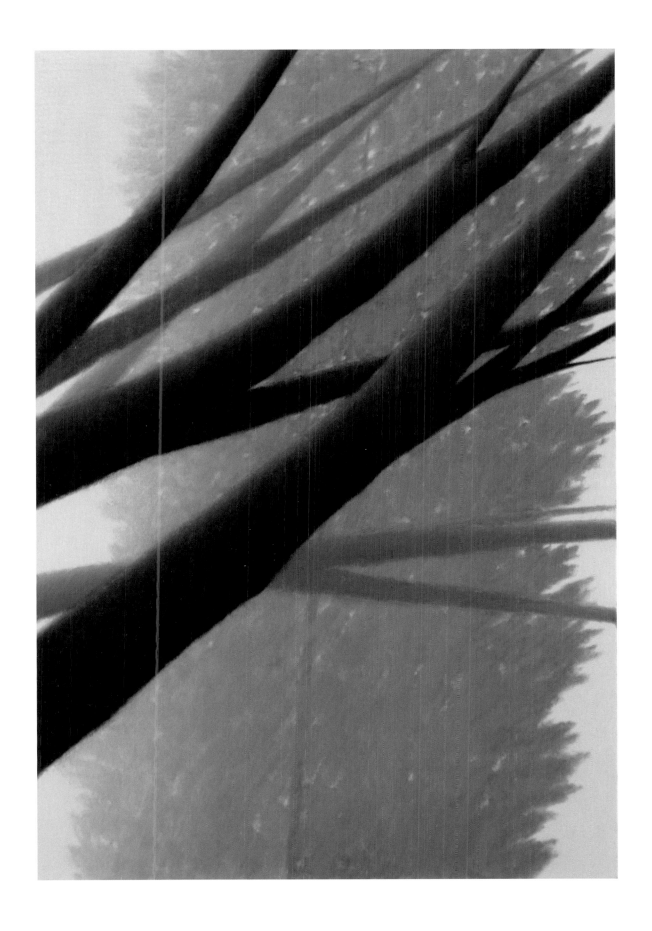

PLATE 101
Branches near Sharon, 2005
oil on canvas, 29 × 20

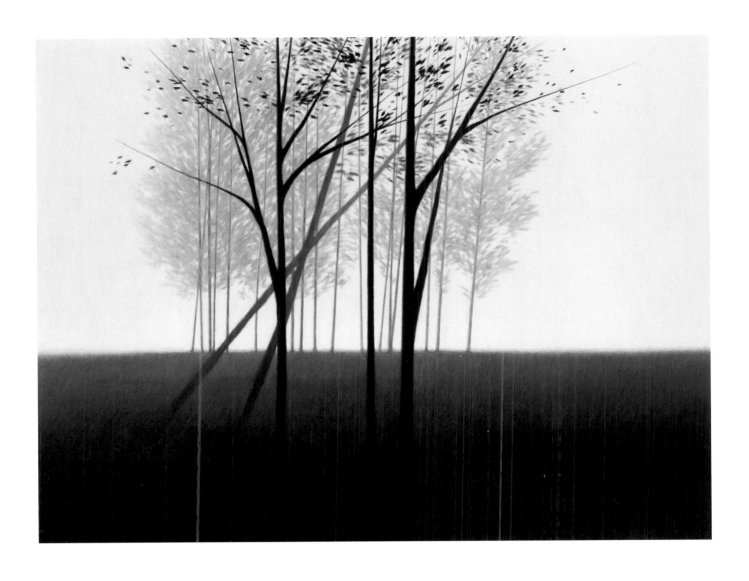

PLATE 102
Afternoon with Black and Gray Trees, 2005
oil on canvas, 30 × 40

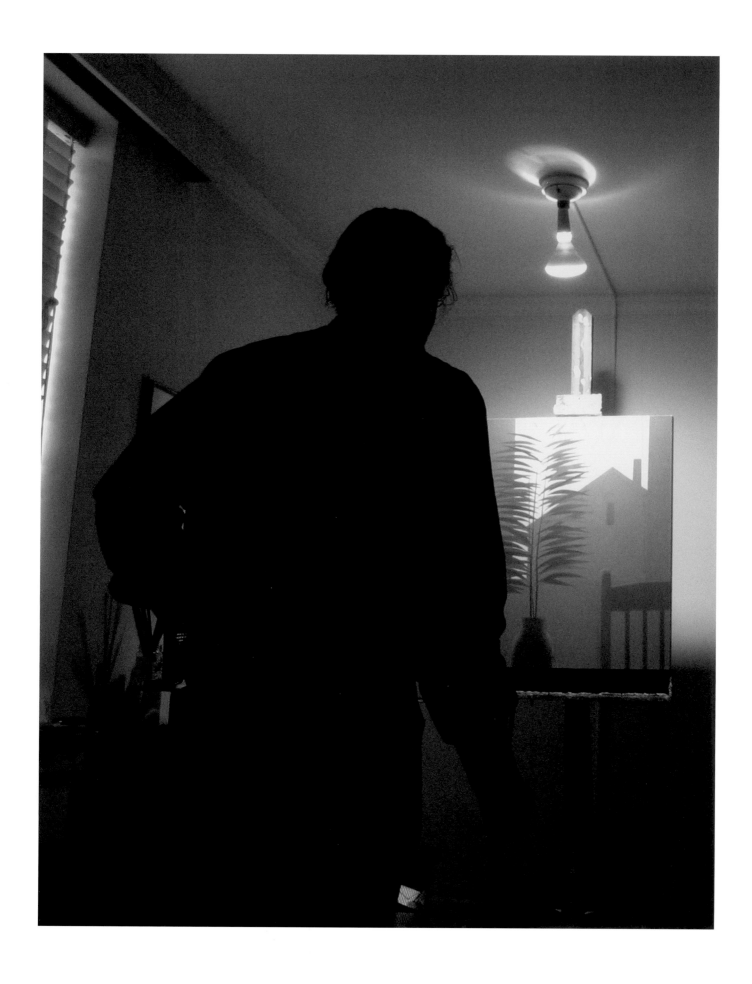

Robert Kipniss at his easel, 2006
Photograph by Benjamin Kipniss

Notes from the Studio

When I was nineteen I made two important decisions. One was that I would spend my life as a painter. The other was drawn from my belief that accomplishment does not come from bursts of activity but rather from doing a day's work every day. As I turn seventy-five, I know I have done just that. My passion has remained true, and I have lived my life as I dreamed of doing when I was very young.

My early works were crude and energetic wide-eyed explorations that came forth irrepressibly, obviously untutored, clearly determined, and confident. At that youthful time I had no idea the work was either crude or explorative. I was convinced I was "doing it," that I was a mature, productive artist.

Because I would never put myself in the position of a student receiving instruction, there were many things I had to improvise as the need to learn them arose. In retrospect these improvisations were often clumsy, but they were mine, original, and arrived at for a specifically expressive purpose. Sometimes my blunders led me to oddly interesting solutions.

I didn't like the feel of working over dried paint so it was necessary for me, in those earliest years, to finish each painting the day I started it. Because of this I couldn't work too large, thirty by forty inches was about the largest I could manage within the parameters of one day, one painting. Also, I disliked seeing passages of a painting disrupted by light reflecting from certain brushstrokes, and I began painting in a manner where my brushwork was almost entirely vertical, or

slanted nearly so. Further, needing to control my light source, I installed a 125-watt floodlight as a ceiling fixture, just like the ones that were being used in the galleries. Then I could work under the same circumstances in which the paintings would eventually be seen. To increase my control I covered the windows with an opaque oil cloth. In later years, in at least two successive studios, I painted the windows black. Upon entering my studio there was never a doubt that it was a place of extreme seclusion, in which the only possible focus was the area where the single light was directed: the easel. Whatever might be happening in my life, when I enter my studio the world disappears.

Until 1960 almost all of my paintings were on Masonite because it was inexpensive. By 1961 the accumulation of finished work was choking our little apartment. One day I looked the paintings over carefully and selected 600 to take to the building's basement and put in the furnace. I remember using a shovel for the smaller ones, to put them deeper into the large fire. It was hard work to create those paintings, and it was hard work to destroy them.

Looking at the transparencies for this book from mid-1963 on, when I no longer had to work evenings to support my life as an artist, I see certain changes evolving in my images as I began using some of my newly idle evening hours to draw. Working from a combination of imagination and memory, and also sketching in Central Park, the drawings and paintings led each other in mutual development. The compositions became more complex, as did my technique. And there was an added intensity to the atmosphere in each painting as I began experimenting with a greater degree of abstraction in my representational themes.

Around 1960–61, I began to paint over dried paint, and found that this greatly opened up the range of painterly possibilities, from adding another dimension of texture to incorporating underpainting into succeeding layers. I began to have several canvases in progress so that there would always be one with a dry surface to work over. In the mid-sixties I began to coat the white gesso face of the canvases with a turpentine dilution of oil paint mixed in neutral tones. It occurred to me, when I realized how much I preferred working over dry paint, that I could begin a new painting on a painted surface. (I didn't know this had been a technique in use for hundreds of years.) Now I no longer completed a painting in one day. With the added complexity of technique there came an added complexity of content, an opportunity to reflect instead of pour out, a growth of another kind of intensity, an amalgam of reflection and instinct. As I could allow myself to see more into the work in progress, then I could do more, always reaching, always self-critical.

In the late 1960s I began making prints, a few drypoints, but mostly lithographs. To do this I needed my original drawings as well as photos of my paintings, since possibly one or another at some later time might become a source from which a lithograph could graphically expand. Often a favorite painting would not be workable as graphic. This wasn't predictable until I had a photo, and then it became immediately obvious. With a simple Polaroid camera I could take a picture and immediately see if I had an adequate record of the painting. But these pictures had to be taken from a slightly distorting angle to avoid the bounce-back reflection of the flash, and a photo of this minimum quality could not be used for reproduction. These are the only photos I have of most of my paintings. In these early years it never occurred to me to have a photographic record of my work, being totally concerned with the work at hand.

Four fortunate happenstances that enhance this book were my associations with Hexton Gallery in New York in the nineties; Beadleston Galleries, also in New York, from 1999 to 2003; Weinstein Gallery in San Francisco, from the late nineties to the present; and Gerhard Wurzer Gallery in Houston, Texas, from the late eighties to the present.

These galleries had professional photographers make many transparencies of my paintings during those years, and without these this book would not be possible. As for the earliest years I have kept some key paintings, paintings that were dear to me because they each represented a breakthrough of one kind or another. A few exist because they are poignant reminders of my perseverance during a difficult time, when I didn't know if things would ever get better. Having participated in the process of creating this book I am surprised to see the wholeness, the one shape, formed by the various points of my gradual evolution. There was never a morning when I could know what that day's work would bring. And after all these years, with no diminished eagerness, I continue.

ROBERT KIPNISS
Ardsley-on-Hudson, New York

List of Plates

PLATE 1
Intimations of the North Country, 1950
oil on panel, 36 × 38
Private collection. Exhibited: *Taking Time*,
Weinstein Gallery, San Francisco, California.
2001

PLATE 2
Self-portrait, 1953
oil on panel, 24 × 18

PLATE 3
Red Grass, 1955
oil on panel, 18 × 24
Collection of Rowland Weinstein. Exhibited:
Taking Time, Weinstein Gallery, San Francisco,
California, 2001

PLATE 4
Self-portrait: Petersburg, Virginia, 1957
oil on canvas, 24 × 24
Collection of the National Academy Museum,
New York, New York. Exhibited: *Robert Kip-
niss: A Retrospective*, The Wichita Falls Art
Museum, Wichita Falls, Texas, 1997

PLATE 5
Green Trees in Virginia, 1958
oil on panel, 30 × 40
Collection of the Hon. Steven Bordner.
Exhibited: *Robert Kipniss: A Retrospective*,
The Wichita Falls Art Museum, Wichita Falls,
Texas, 1997

PLATE 6
Freight Spur, 1958
oil on panel, 27 × 32¼
Collection of Mr. and Mrs. Ivan Kipniss

PLATE 7
Large Trees at Dusk, 1962
oil on canvas, 36 × 40
Exhibited SKH Gallery, Great Barrington,
Massachusetts, 2006

PLATE 8
Table with Pitcher, 1964
oil on canvas, 24 × 24
Collection of the Weinstein Gallery. Exhibited:
Taking Time, Weinstein Gallery, San Francisco,
California, 2001

PLATE 9
Leaves and Trees, 1965
oil on canvas, 24 × 16
Collection of Mr. and Mrs. Ivan Kipniss

PLATE 10
Hillside, Ohio, 1966
oil on canvas, 40 × 48
Collection of Marvin and Charlene Fogel

PLATE 11
Ohio Memories, 1967
oil on canvas, 30¼ × 40¼
Exhibited: FAR Gallery, New York,
New York, 1967
Exhibited SKH Gallery, Great Barrington,
Massachusetts, 2006

PLATE 12
Window with Flowers, 1968
oil on canvas, 38 × 30
Collection of Larry and Laura Skinner. Exhibited: FAR Gallery, New York, New York, 1968; *Robert Kipniss: A Retrospective*, The Wichita Falls Art Museum, Wichita Falls, Texas, 1997

PLATE 13
Backyard II, 1971
oil on canvas, 36 × 48
Collection of Paul and Susan Beck

PLATE 14
Secrets, 1978
oil on canvas, 30 × 36
Collection of Janet Lippmann

PLATE 15
Spring Secrets, 1981
oil on canvas, 40 × 48
Collection of Mitchell and Lois Levey. Exhibited: Hirschl and Adler Gallery, New York, New York, 1981

PLATE 16
Through Bedroom Curtains, 1981
oil on canvas, 40 × 36
Collection of Janet Lippmann. Exhibited: Hirschl and Adler Gallery, New York, New York, 1981

PLATE 17
Untitled #2, 1983–1994
oil on canvas, 34 × 40
Collection of Gerhard Wurzer Gallery

PLATE 18
Landscape with Three Houses, 1986
oil on canvas, 32 × 27
Private collection

PLATE 19
Alleys, Springfield, 1986
oil on canvas, 36 × 40
Private collection. Exhibited: Hexton Gallery, New York, New York, 1995; *Robert Kipniss: A Retrospective*, The Wichita Falls Art Museum, Wichita Falls, Texas, 1997; *Painter/Printmaker*, Weinstein Gallery, San Francisco, California, 2000

PLATE 20
Landscape with Entrance, 1986
oil on canvas, 24 × 20
Private collection

PLATE 21
Neighbors, 1987
oil on canvas, 41 × 41
Collection of the Dubuque Museum of Art, Dubuque, Iowa, from a purchase award by the Speicher-Hassam Fund at the American Academy of Arts and Letters exhibition, New York, New York, 1988

PLATE 22
Road to Middleburgh, 1987
oil on canvas, 24 × 20
Private collection

PLATE 23
The White Chair, 1991
oil on canvas, 48 × 40
Collection of Henry and Nancy Schacht. Exhibited: Hexton Gallery, New York, New York, 1995

PLATE 24
Springfield, O., 1991
oil on canvas, 40 × 36
Private collection. Exhibited: *Robert Kipniss: A Retrospective*, The Wichita Falls Art Museum, Wichita Falls, Texas, 1997; Hexton Gallery, New York, New York, 1998

PLATE 25
Shadowed Path, 1992
oil on canvas, 26¾ × 31½
Private collection. Exhibited: *Taking Time*, Weinstein Gallery, San Francisco, California, 2001

PLATE 26
Hillside, 1994
oil on canvas, 40 × 36
Private collection. Exhibited: Hexton Gallery, New York, New York, 1998; *Painter/Printmaker*, Weinstein Gallery, San Francisco, California, 2000

PLATE 27
Central Park, 1995
oil on canvas, 14 × 11
Collection of James F. White

PLATE 28
Vase, Chair, and Leaves, 1995
oil on panel, 20 × 16
Collection of Steven Fox and Laurie Newman.
Exhibited: The Century Association, New
York, New York, 1996; Hexton Gallery,
New York, New York, 1997

PLATE 29
Easel with Trees and Moon, 1995
oil on canvas, 27¾ × 22
Collection of the Hon. Steven Bordner.
Exhibited: *Robert Kipniss: A Retrospective*,
The Wichita Falls Art Museum, Wichita Falls,
Texas, 1997

PLATE 30
Composition: Trees, 1995
oil on canvas, 20 × 16
Private collection. Exhibited: Hexton Gallery,
New York, New York, 1995

PLATE 31
Central Park: Toward the Reservoir, 1995
oil on canvas, 14 × 11
Collection of the Everson Museum of Art,
Syracuse, New York

PLATE 32
Clear Vase and Landscape, 1995
oil on canvas, 22 × 28
Collection of Henry and Nancy Schacht.
Exhibited: *Robert Kipniss: A Retrospective*,
The Wichita Falls Art Museum, Wichita Falls,
Texas, 1997; Hexton Gallery, New York,
New York, 1999

PLATE 33
Trees and Trees, 1996
oil on canvas, 28 × 22
Exhibited: Hexton Gallery, New York, New
York, 1996; *Robert Kipniss: A Retrospective*,
The Wichita Falls Art Museum, Wichita Falls,
Texas, 1997; *Painter/Printmaker*, Weinstein
Gallery, San Francisco, California, 2000

PLATE 34
Looking Through II, 1996
oil on panel, 16 × 12
Collection of Susan Hodge. Exhibited: Gerhard
Wurzer Gallery, Houston, Texas, 1997

PLATE 35
Still Life with Kettle and Cup, 1997
oil on canvas, 24 × 18
Collection of John Hartje and Carol Camper

PLATE 36
Three Trees, 1998
oil on canvas, 36 × 40
Exhibited: *Robert Kipniss*, Butler Institute of
American Art, Youngstown, Ohio, 1999;
Painter/Printmaker, Weinstein Gallery, San
Francisco, California, 2000; Harmon-Meek
Gallery, Naples, Florida, 2002; SKH Gallery,
Great Barrington, Massachusetts, 2004

PLATE 37
Before Spring, 1998
oil on canvas, 32 × 28
Exhibited: *Robert Kipniss*, Butler Institute of
American Art, Youngstown, Ohio, 1999;
Beadleston Gallery, New York, New York,
2001; Harmon-Meek Gallery, Naples, Florida,
2006

PLATE 38
Winter, 1998
oil on panel, 24 × 24
Collection of Rowland Weinstein. Exhibited:
Robert Kipniss, Butler Institute of American
Art, Youngstown, Ohio, 1999

PLATE 39
Window with Bench and Tree, 1998
oil on canvas, 28 × 22
Private collection

PLATE 40
Still Life with White Kettle, 1998
oil on panel, 20 × 25
Private collection. Exhibited: *Robert Kipniss*,
Butler Institute of American Art, Youngstown,
Ohio, 1999; Beadleston Gallery, New York,
New York, 2001

PLATE 41
Aloft, 1999
oil on canvas, 32 × 22
Private collection. Exhibited: *Robert Kipniss*,
Butler Institute of American Art, Youngstown,
Ohio, 1999; Beadleston Gallery, New York,
New York, 2001

PLATE 42
Window at Dusk, 1999
oil on canvas, 36 × 24¾
Private collection. Exhibited: *Robert Kipniss*,
Butler Institute of American Art, Youngstown,
Ohio, 1999; Beadleston Gallery, New York,
New York, 2001

PLATE 43
Mist, 1999
oil on canvas, 20 × 24
Private collection. Exhibited: *Robert Kipniss*,
Butler Institute of American Art, Youngstown,
Ohio, 1999; Hexton Gallery, New York, New
York, 1999; *Painter/Printmaker*, Weinstein
Gallery, San Francisco, California, 2000

PLATE 44
The Artist's Studio, 1999
oil on canvas, 48 × 40
Private collection. Exhibited: *Taking Time*,
Weinstein Gallery, San Francisco, California,
2001; *Robert Kipniss*, Harmon-Meek Gallery,
Naples, Florida, 2002

PLATE 45
Little Compton, 1999
oil on canvas, 36 × 40
Private collection. Exhibited: Beadleston
Gallery, New York, New York, 2001

PLATE 46
Splash, 1999
oil on panel, 20 × 16
Collection of James F. White. Exhibited:
Robert Kipniss, Butler Institute of American
Art, Youngstown, Ohio, 1999; Beadleston
Gallery, New York, New York, 2001

PLATE 47
The Far House, 1999
oil on panel, 25 × 20
Private collection. Exhibited: *Robert Kipniss*,
Butler Institute of American Art, Youngstown,
Ohio, 1999; Beadleston Gallery, New York,
New York, 2001; *Taking Time*, Weinstein
Gallery, San Francisco, California, 2001

PLATE 48
Interior with Leaves, 1999
oil on canvas, 24 × 24
Private collection. Exhibited: Beadleston
Gallery, New York, New York, 2001

PLATE 49
Silver Morning, 2000
oil on canvas, 36 × 40
Collection of Henry and Nancy Schacht.
Exhibited: Beadleston Gallery, New York, New
York, 2001

PLATE 50
Toward Long Ridge, 2000
oil on panel, 24 × 20
Private collection. Exhibited: Beadleston
Gallery, New York, New York, 2001

PLATE 51
Approaching, 2000
oil on canvas, 32 × 22
Private collection. Exhibited: Beadleston
Gallery, New York, New York, 2001

PLATE 52
Summer Evening, 2000
oil on canvas, 40 × 32
Private collection. Exhibited: Beadleston
Gallery, New York, New York, 2001

PLATE 53
Interior with Chair and Standing Lamp,
2000
oil on canvas, 40 × 36
Exhibited: *Robert Kipniss: Seen in Solitude*,
New Orleans Museum of Art, 2006

PLATE 54
Looking Through IV, 2000
oil on canvas, 40 × 32¼
Exhibited: Beadleston Gallery, New York,
New York, 2001; *Intaglio and Oil*, Weinstein
Gallery, San Francisco, California, 2004

PLATE 55
A Small Field, 2000 .
oil on canvas, 24 × 18
Exhibited: Beadleston Gallery, New York,
New York, 2001; *Intaglio and Oil*, Weinstein
Gallery, San Francisco, California, 2004

PLATE 56
Trees with Distant Mist, 2000
oil on canvas, 20 × 16
Private collection. Exhibited: *Painter/Print-
maker*, Weinstein Gallery, San Francisco, Cali-
fornia, 2000

PLATE 57
Together, Solitary, 2000
oil on canvas, 16 × 12
Private collection. Exhibited: Beadleston
Gallery, New York, New York, 2001

PLATE 58
Hillside Illusions II, 2001
oil on canvas, 32 × 22
Exhibited: Beadleston Gallery, New York, New
York, 2003; *Robert Kipniss: Seen in Solitude*,
New Orleans Museum of Art, 2006

PLATE 59
Evening, 2001
oil on canvas, 24 × 18
Private collection. Exhibited: The National
Academy Annual, New York, New York,
2000; *Taking Time*, Weinstein Gallery, San
Francisco, California, 2001

PLATE 60
Still Life with Curtains and Tree, 2001
oil on panel, 24 × 16
Collection of Henry and Nancy Schacht.
Exhibited: Beadleston Gallery, New York, New
York, 2003

PLATE 61
Shelter, 2001
oil on canvas, 32 × 22
Private Collection. Exhibited: *Robert Kipniss:
Seen in Solitude*, New Orleans Museum of Art,
2006

PLATE 62
Winter II, 2001
oil on canvas, 32 × 22
Private collection. Exhibited: Beadleston
Gallery, New York, New York, 2003

PLATE 63
Springfield, O. Sheds, 2001
oil on canvas, 28 × 32
Private collection. Exhibited: *Taking Time*,
Weinstein Gallery, San Francisco, California,
2001

PLATE 64
Still Life with Dark Window, 2002
oil on canvas, 36 × 25
Private collection. Exhibited: Beadleston
Gallery, New York, New York, 2003

PLATE 65
Evening Figures, 2002
oil on canvas, 29¼ × 40
Exhibited: Beadleston Gallery, New York,
New York, 2003; *Intaglio and Oil*, Weinstein
Gallery, San Francisco,
California, 2004

PLATE 66
Fields in Mist, 2002
oil on panel, 24 × 16
Exhibited: *Robert Kipniss: Seen in Solitude*,
New Orleans Museum of Art, 2006

PLATE 67
Window with Spoon, 2002
oil on canvas, 24 × 20
Private collection. Exhibited: Beadleston
Gallery, New York, New York, 2003; Harmon-
Meek Gallery, Naples, Florida, 2006

PLATE 68
Trees, 2002
oil on canvas, 40 × 29
Exhibited: Beadleston Gallery, New York,
New York, 2003

PLATE 69
Still Life with Two Vases, 2002
oil on panel, 24 × 16
Collection of Henry and Nancy Schacht.
Exhibited: Beadleston Gallery, New York,
New York, 2003

PLATE 70
Crossings, 2002
oil on canvas, 24 × 18
Exhibited: Beadleston Gallery, New York,
New York, 2003: *Intaglio and Oil*, Weinstein
Gallery, San Francisco, California, 2004

PLATE 71
Vase and Green Leaves, 2002
oil on panel, 24 × 16
Exhibited: Beadleston Gallery, New York,
New York, 2003

PLATE 72
Appearing I, 2002
oil on canvas, 36 × 25
Exhibited: Beadleston Gallery, New York,
New York, 2003

PLATE 73
Splash III, 2003
oil on canvas, 28 × 22
Exhibited: *Robert Kipniss: Seen in Solitude*,
New Orleans Museum of Art, 2006

PLATE 74
Premonitions, 2003
oil on canvas, 25 × 36¼
Exhibited: *Intaglio and Oil*, Weinstein Gallery,
San Francisco, California, 2004

PLATE 75
Appearing II, 2004
oil on panel, 24 × 16
Exhibited: *Robert Kipniss: Seen in Solitude*,
New Orleans Museum of Art, 2006

PLATE 76
On Point, 2004
oil on panel, 14 × 12

PLATE 77
Window with Kettle and Vase, 2004
oil on canvas, 24 × 18
Exhibited: *Robert Kipniss: Seen in Solitude*,
New Orleans Museum of Art, 2006

PLATE 78
Nocturne with Six Trees II, 2004
oil on panel, 24 × 20
Exhibited: *Robert Kipniss: Seen in Solitude*,
New Orleans Museum of Art, 2006

PLATE 79
Tribute, 2004
oil on panel, 20 × 14
Exhibited: *Robert Kipniss: Seen in Solitude*,
New Orleans Museum of Art, 2006

PLATE 80
The Balanced Rock, 2004
oil on canvas, 40 × 36
Exhibited: *Robert Kipniss: Seen in Solitude*,
New Orleans Museum of Art, 2006

PLATE 81
Near the Clearing, 2004
oil on canvas, 47¾ × 39¾
Private Collection

PLATE 82
Table-top Nocturne, 2004
oil on canvas, 24 × 20
Exhibited: *Robert Kipniss: Seen in Solitude*,
New Orleans Museum of Art, 2006

PLATE 83
Still Life with Glass and Cup, 2004
oil on panel, 14 × 12

PLATE 84
Intervention, 2004
oil on canvas, 25 × 36
Exhibited: *Robert Kipniss: Seen in Solitude*,
New Orleans Museum of Art, 2006

PLATE 85
The Stage, 2004
oil on canvas, 22 × 28
Exhibited: *Robert Kipniss: Seen in Solitude*,
New Orleans Museum of Art, 2006

PLATE 86
Green, Green, 2004
oil on canvas, 32 × 22
Exhibited: *Robert Kipniss: Seen in Solitude*,
New Orleans Museum of Art, 2006

PLATE 87
Silver Morning II, 2004
oil on canvas, 22 × 28
Collection of Peter M. Wolf. Exhibited:
The Century Association, New York,
New York, 2005

PLATE 88
At Shire, 2004
oil on canvas, 18 × 24
Private collection. Exhibited: *Intaglio and Oil*,
Weinstein Gallery, San Francisco, California,
2004

PLATE 89
Presentation: Trees, 2004
oil on canvas, 28 × 22
Exhibited: *Robert Kipniss: Seen in Solitude*,
New Orleans Museum of Art, 2006

PLATE 90
Window with Hanging Plant, 2004
oil on canvas, 32 × 22
Exhibited: *Intaglio and Oil*, Weinstein Gallery,
San Francisco, California, 2004

PLATE 91
Testament, 2005
oil on canvas, 28 × 32
Exhibited: *Robert Kipniss: Seen in Solitude*,
New Orleans Museum of Art, 2006

PLATE 92
Green Slope, 2005
oil on canvas, 25 × 36
Exhibited: *Robert Kipniss: Seen in Solitude*,
New Orleans Museum of Art, 2006

PLATE 93
Interior with Window and Pot, 2005
oil on canvas, 29 × 22
Exhibited: *Robert Kipniss: Seen in Solitude*,
New Orleans Museum of Art, 2006

PLATE 94
Study in Gray and Green, 2005
oil on canvas, 24 × 18
Exhibited: *Robert Kipniss: Seen in Solitude*,
New Orleans Museum of Art, 2006

PLATE 95
Springfield, O. III, 2005
oil on canvas, 20¼ × 22
Exhibited: *Robert Kipniss: Seen in Solitude*,
New Orleans Museum of Art, 2006

PLATE 96
Vase and Leaves I, 2005
oil on panel, 20 × 14
Exhibited: *Robert Kipniss: Seen in Solitude*,
New Orleans Museum of Art, 2006

PLATE 97
Vase and Leaves II, 2005
oil on panel, 24 × 16
Exhibited: *Robert Kipniss: Seen in Solitude*,
New Orleans Museum of Art, 2006

PLATE 98
Vase and Leaves III, 2005
oil on canvas, 23 × 18
Exhibited: *Robert Kipniss: Seen in Solitude*,
New Orleans Museum of Art, 2006

PLATE 99
Vase and Leaves IV, 2005
oil on canvas, 20¼ × 22
Exhibited: *Robert Kipniss: Seen in Solitude*,
New Orleans Museum of Art, 2006

PLATE 100
Poised, 2005
oil on panel, 14 × 12

PLATE 101
Branches near Sharon, 2005
oil on canvas, 29 × 20
Exhibited: *Robert Kipniss: Seen in Solitude*,
New Orleans Museum of Art, 2006

PLATE 102
Afternoon with Black and Gray Trees, 2005
oil on canvas, 30 × 40
Exhibited: *Robert Kipniss: Seen in Solitude*,
New Orleans Museum of Art, 2006

Selected Publications,
Collections & Exhibitions

Selected Publications

Monographs

Grace, Trud e A., and Thomas Piché Jr. *Robert Kipniss: Intaglios, 1982–2004.*
New York and Manchester: Hudson Hills Press, 2004.

Lunde, Karl *Robert Kipniss:* The Graphic Work. New York: Abaris Books,
1980.

Exhibition Catalogue

Piersol, Dariel, "Seen in Solitude—Robert Kipniss Prints from the James F.
White Collection", New Orleans Museum of Art, New Orleans, 2005.

Periodicals

Boughton, Kathryn. "Sharon Artist's 'Solitude' Shines in New Orleans Exhibit,"
The Litchfield (Connecticut) County Times, 7 April 2006, Northwest Corner
Journal section.

Bride, Edward. "Robert Kipniss *Artist*," *The Artful Mind* (August 2006): 11.

Depew, Ned. "Robert Kipniss: A Defining Moment," *Berkshire Home and Style*
(October 2006): n.p.

Epworth, Marsden. "Leaving in the Unseen," *The Lakeville (Connecticut) Jour-
nal*, 26 October 2006, B4.

Frome, Shelley. "Artistic Integrity and the Magic of the Moment at SKH," *The
Country and Abroad* (November 2006): n.p.

Greben, Deidre Stein. "An Artistic Gift, from New York to New Orleans,"
Newsday, 5 March 2006, B6.

Hershenson, Roberta. "Show Marked by Poignancy," *New York Times*, 26 February 2006, Westchester edition, Arts and Entertainment section.

Morel, Gregory. "SKH Gallery Robert Kipniss: Early Work" *The Berkshire Eagle*, 21 October 2006, D3.

Nachbar, Dana. "Acclaimed Artist Selected for Reopening Exhibit at New Orleans Museum of Art," **arts***news* (published by The Westchester Council on the Arts) (March 2006): A5.

"New Acquisitions: Watercolors, Drawings, and Prints through November 13, 2006 at New Britain Museum of Art," *Journal of the Print World* (fall 2006): 34.

"Robert Kipniss Intaglios 1982–2004," *Journal of the Print World* (fall 2004): 23.

"Seen in Solitude: Robert Kipniss Prints from the James F. White Collection, August 24 through September 24, 2006 at Joel and Lila Harnett Museum of Art, University of Richmond Museums, Richmond, VA," *Journal of the Print World* (fall 2006): 51.

"Seen in Solitude: Robert Kipniss Prints from the James F. White Collection, Dec. 10, 2006–Feb. 11, 2007 at Orlando Museum of Art, FL," *Journal of the Print World* (fall 2006): 36.

"SKH," *The Artful Mind* (October 2006): n.p.

"SKH Gallery, Great Barrington, MA, Distinguished American Artist Robert Kipniss at SKH," *The Country and Abroad* (October 2006): 46.

"Springfield Art Museum given works by Kipniss" *News-Leader* (Missouri), 14 November 2003.

Tuohy, Laurel. "Sharon Artist's Rediscovered Early Works in Great Barrington Show," *The Litchfield (Connecticut) County Times*, 13 October 2006, front section.

Selected Public Collections (Paintings, Prints, Drawings)

Achenbach Foundation for Graphic Arts, The Fine Arts Museums of San Francisco, California Palace of the Legion of Honor

Albright-Knox Art Gallery, Buffalo, New York

Arkansas State University Permanent Collection, State University, Arkansas

The Art Institute of Chicago, Chicago, Illinois

Art Museum of Western Virginia, Roanoke, Virginia

Art Students League of New York, New York

Bates College Museum of Art, Lewiston, Maine

The Berkshire Museum, Pittsfield, Massachusetts

Bibliothèque nationale de France, Paris

The British Museum, London

Brooklyn Museum of Art, Brooklyn, New York

The Butler Institute of American Art, Youngstown, Ohio

Canton Art Institute, Canton, Ohio

Carnegie Museum of Art, Pittsburgh, Pennsylvania

The Century Association, New York, New York

The Cleveland Museum of Art, Cleveland, Ohio

De Cordova Museum and Sculpture Park, Lincoln, Massachusetts

The Denver Art Museum, Denver, Colorado

The Detroit Institute of Arts, Detroit, Michigan

Dubuque Museum of Art, Dubuque, Iowa

Elvehjem Museum of Art, University of Wisconsin-Madison, Wisconsin

Everson Museum of Art, Syracuse, New York

Fitzwilliam Museum, University of Cambridge, Cambridge, England

Flint Institute of Arts, Flint, Michigan

Frederick R. Weisman Art Museum, University of Minnesota, Minneapolis

Gibbes Museum of Art, Charleston, South Carolina

Harvard University Art Museums, Cambridge, Massachusetts

The Herbert F. Johnson Museum of Art, Cornell University, Ithaca, New York

Indianapolis Museum of Art, Indianapolis, Indiana

Iris & B. Gerald Cantor Center for Visual Arts at Stanford University, Stanford, California

Jane Voorhees Zimmerli Art Museum, Rutgers, The State University of New Jersey, New Brunswick

Lakeview Museum of Arts and Sciences, Peoria, Illinois

Library of Congress, Washington, D.C.

Los Angeles County Museum of Art, Los Angeles, California

The Marion Koogler McNay Art Museum, San Antonio, Texas

The Metropolitan Museum of Art, New York, New York

Minnesota Museum of American Art, Saint Paul, Minnesota

Mint Museum of Art, Charlotte, North Carolina

Mississippi Museum of Art, Jackson, Mississippi

Museo de Arte Moderno La Tertulia, Cali, Colombia

Museum of Art, Rhode Island School of Design, Providence

Museum of Fine Arts, Boston, Massachusetts

The Museum of Fine Arts, Houston, Texas

National Academy of Design, New York, New York

National Museum of American Art, Washington, D.C.

The Nelson-Atkins Museum of Art, Kansas City, Missouri

The New Britain Museum of American Art, New Britain, Connecticut

New Orleans Museum of Art, New Orleans, Louisiana

The New York Public Library, Print Collection, New York, New York

Orlando Museum of Art, Orlando, Florida

Philadelphia Museum of Art, Pennsylvania

Pinakothek der Moderne, Staatliche Graphische Sammlung, Munich

Portland Art Museum, Portland, Oregon

Print Club of Albany, Albany, New York

Royal Society of Painter-Printmakers, London (diploma piece); housed at the Ashmolean Museum, Oxford

Society of American Graphic Artists (SAGA), New York, New York

Southern Alleghenies Museum of Art, Loretto, Pennsylvania

Springfield Art Museum, Springfield, Missouri

Springfield Museum of Art, Springfield, Ohio

Tacoma Art Museum, Tacoma, Washington

Victoria and Albert Museum, London

Virginia Museum of Fine Arts, Richmond, Virginia

Whitney Museum of American Art, New York, New York

Wichita Falls Museum and Art Center, Wichita Falls, Texas

Wittenberg University, Springfield, Ohio

Yale University Art Gallery, New Haven, Connecticut

Selected One-Man Shows (Paintings, Prints, Drawings)

Marion Koogler McNay Art Museum, San Antonio, Texas, 2007

Weinstein Gallery, San Francisco, California, 2007, 2004, 2002, 2001, 2000

Millennia Fine Arts, Orlando, Florida, 2007

Orlando Museum of Art, Orlando, Florida, 2006

Joel and Lila Harnett Museum of Art, University of Richmond Museums, Richmond, Virginia, 2006

New Orleans Museum of Art, New Orleans, Louisiana, 2006 (A retrospective of prints plus thirty-five recent paintings)

Harmon-Meek Gallery, Naples, Florida, 2006, 2002

SKH Gallery, Great Barrington, Massachusetts, 2006, 2005, 2004 (2006: paintings and drawings from the 1960s)

The Old Print Shop, New York, New York, 2004

Springfield Art Museum, Springfield, Missouri, 2003

Beadleston Gallery, New York, New York, 2003, 2001

Wichita Falls Museum and Art Center, Wichita, Texas, 1997 (A retrospective of paintings and graphics, 1950s–1990s)

Bassenge Gallery, Berlin, Germany, 1999

The Butler Institute of American Art, Youngstown, Ohio, 1999

Tyler Museum of Art, Tyler, Texas, 1999

Gerhard Wurzer Gallery, Houston, Texas, 1999, 1997, 1988, 1986, 1981

Molesey Gallery, East Molesey, Surrey, England, 1999, 1995

Redfern Gallery, London, 1999, 1995

Davidson Gallery, Seattle, Washington, 1999, 1993, 1983, 1982

Gallery New World, Düsseldorf, Germany, 1998, 1995

Jane Haslem Gallery, Washington, D.C., 1998, 1976

Hexton Gallery, New York, New York, 1997, 1996, 1995, 1994

Venable/Neslage Gallery, Washington, D.C., 1997, 1995

The Century Association, New York, New York, 1996

Taunhaus Gallery, Osaka and Kanazawa, Japan, 1994

Laura Craig Gallery, Scranton, Pennsylvania, 1993, 1991, 1990

Wittenberg University, Springfield, Ohio, 1993, 1979

Theodore B. Donson Gallery, New York, New York, 1992

OK Harris Works of Art, New York, New York, 1991

Enatsu Gallery, Tokyo, Japan, 1990, 1988, 1987

Illinois College, Jacksonville, Illinois, 1989

Haller-Griffin Gallery, Washington Depot, Connecticut, 1985

Jamie Szoke Gallery, New York, New York, 1985

Springfield Museum of Art, Springfield, Ohio, 1985, 1983

Nancy Teague Gallery, Seattle, Washington, 1983, 1982

ICA, Nagoya, Japan, 1984

Payson/Weisberg Gallery, New York, New York, 1983, 1981

Bruce Museum of Arts and Science, Greenwich, Connecticut, 1981

Gage Gallery, Washington, D.C., 1981

Hirschl & Adler Galleries, New York, New York, 1980, 1977

Museo de Arte Moderno La Tertulia, Cali, Colombia, 1980, 1975

Canton Art Institute, Canton, Ohio, 1979

Associated American Artists (AAA), New York, New York, 1977 (A graphics
retrospective, 1967–1977)

G.W. Einstein Gallery, New York, New York, 1977, 1976

Galería de Arte, Lima, Peru, 1977

Galería San Diego, Bogotá, Colombia, S.A., 1977, 1975

"9" Galería de Arte, Lima, Peru, 1976

Centro de Arte Actual, Pereira, Colombia, 1975

Kalamazoo Institute of Arts, Kalamazoo, Michigan, 1975

Xochipili Gallery, Rochester, Michigan, 1975

FAR Gallery, New York, New York, 1975, 1972, 1970, 1968

The Contemporaries, New York, New York, 1967, 1966, 1960, 1959

Allen R. Hite Institute, University of Louisville, Kentucky, 1965

Alan Auslander Gallery, New York, New York, 1963

Harry Salpeter Gallery, New York, New York, 1953

Joe Gans Gallery, New York, New York, 1951

Selected Group Shows

New Britain Museum of American Art, New Britain, Connecticut, *Recent Acquisitions: Watercolors, Drawings and Prints*, 2006

The Art Students League of New York, New York, *Highlights from the Permanent Collection*, touring from 2006 to 2008

Venues: Owensboro Museum of Art, Owensboro, Kentucky; Cape Museum of
Fine Arts, Dennis, Massachusetts; Brunnier Art Museum, Ames, Iowa; Southern
Vermont Art Center, Manchester, Vermont; Hillstrom Museum of Art, St. Peter,
Minnesota; Lowe Art Museum, Coral Gables, Florida; Pensacola Museum of
Art, Pensacola, Florida; Fort Wayne Museum of Art, Fort Wayne, Indiana; The
Long Island Museum of American Art, Stony Brook, New York

The Jane Voorhees Zimmerli Art Museum, Rutgers, The State University of New
Jersey, New Brunswick, *The Color of Night*, 2005

The Berkshire Museum, Pittsfield, Massachusetts, *The Power of Place: The Berkshires*, 2005

The Forbes Galleries, New York, New York, *A Record of What Has Been Accomplished: Highlights from the Permanent Collection of the Art Students League of New York*, 2004

Everson Museum of Art, Syracuse, New York, *Object Lessons: Additions to the Collection, 1997–2002*, 2003

Orlando Museum of Art, Orlando, Florida, *Celebrating a Decade of Growth: Selections from the Orlando Museum of Art's Permanent Collections*, 2003

Tacoma Art Museum, Tacoma, Washington, *Pressed: Intaglio*, 2002

USB PaineWebber Art Gallery, New York, New York, *A Century on Paper*, 2002

Art Museum of Western Virginia, Roanoke, Virginia, *Selected Recent Acquisitions*, 2002

New Orleans Museum of Art, New Orleans, Louisiana, *Acquisitions in Prints and Drawings, 1996–2000*, 2001

Royal Academy, London, Royal Academy Summer Show, 2001

The British Museum, London, *Recent Acquisitions*, 2000

National Academy of Design, New York, New York, *Treasures Revealed: Nineteenth- and Twentieth-Century American Works on Paper*, 1999

Fitzwilliam Museum, University of Cambridge, Cambridge, England, *Recent Acquisitions*, 1999

Ashmolean Museum, Oxford, *No Day Without a Line*, Diploma Prints of the Royal Society of Painter-Printmakers, London, 1999

American Academy of Arts and Letters, New York, New York, *Invitational Exhibition*, 1988

Tahir Gallery, New Orleans, Louisiana, *American Self-portraits*, 1981

Museo de Arte Moderno La Tertulia, Cali, Colombia, S.A., *Grabadores Norteamericanos*, 1978

III Bienal Americana de Artes Gráficas, Museo La Tertulia, Cali, Colombia, S.A., 1976

International Exhibition of Original Drawings, Rijeka-Dolac, Yugoslavia, 1976

Kalamazoo Institute of Arts, Kalamazoo, Michigan, 1975

Westmoreland Museum, Pittsburgh, Pennsylvania, 1974, 1973, 1972

Whitney Museum of American Art, New York, New York, *Recent Acquisitions*, 1972

New York Public Library, New York, New York, *Recent Acquisitions*, 1972

American Federation of Arts Traveling Exhibition, *Moods of Light*, 1963–1965: Vanderbilt Gallery, Nashville, Tennessee

Andrew Dickson White Museum, Cornell University, Ithaca, New York

Davenport Municipal Art Gallery, Davenport, Iowa

Utah Museum of Fine Arts, Salt Lake City, Utah

University of Manitoba, Winnipeg, Manitoba, Canada

West Virginia University, Morgantown, West Virginia

Cranbrook Academy of Art, Bloomfield Hills, Michigan

Paul Sargent Gallery, Charlestown, Illinois

Herron Museum of Art, Indianapolis, Indiana, *Painting and Sculpture Today,* 1964

Graham Gallery, New York, New York, *East Coast Landscape,* 1964

Osborne Gallery, New York, New York, *The Contemporary American Landscape,* 1963

Nordness Gallery, New York, New York, *The Artist Depicts the Artist,* 1961

Tweed Gallery, University of Minnesota, Duluth, Minnesota, *Contemporary Artists,* 1962

Art in America, New York, New York, 1961

The Sheldon Swope Gallery, Terre Haute, Indiana, 1961

Massillon Museum, Massillon, Ohio, 1957

Columbus Museum of Art, Columbus, Ohio, 1957

Butler Art Institute, Youngstown, Ohio, *The Annual New Year's Show,* 1953

Honors

Elected to: Royal Society of Painter-Printmakers, London, 1998

National Academy of Design, New York, New York, 1980

Illinois College, Jacksonville, Illinois, Honorary Doctorate, 1989

Wittenberg University, Springfield, Ohio, Honorary Doctorate, 1979